FAMOUS FELINES

**Other books in the Dictionary Series
published by Remember When include:**

The Dictionary of Rock and Pop Names by Mark Beech
Famous Dogs by Fiona Shoop
Great British Fictional Detectives by Russell James
Great British Fictional Villains by Russell James

FAMOUS FELINES
Cats' Lives in Fact and Fiction

by

DAVID ALDERTON

First published in Great Britain in 2009 by
Remember When
an imprint of
Pen & Sword Books Ltd
47 Church Street
Barnsley
South Yorkshire
S70 2AS

Copyright © David Alderton, 2009

ISBN 978-1-84468-033-7

A CIP catalogue record for this book is
available from the British Library

Printed and bound in England
by CPI UK

Typeset in 12/14 Palatino by
Concept, Huddersfield, West Yorkshire

Pen & Sword Books Ltd incorporates the Imprints of Pen & Sword
Aviation, Pen & Sword Maritime, Pen & Sword Military, Wharncliffe
Local History, Pen & Sword Select, Pen & Sword Military Classics,
Leo Cooper, Remember When, Seaforth Publishing and
Frontline Publishing.

For a complete list of Pen & Sword titles please contact
PEN & SWORD BOOKS LIMITED
47 Church Street, Barnsley, South Yorkshire, S70 2AS, England
E-mail: enquiries@pen-and-sword.co.uk
Website: www.pen-and-sword.co.uk

Contents

Introduction

C ATS HAVE lived alongside us for over 8,000 years. From their origins in ancient Egypt, they have been taken around the world, northwards into Europe and Asia, extending eastwards to Japan at an early stage in history. They are then believed to have reached the New World probably on Columbus's first voyage of discovery in 1492. They have been taken by ship to some of the furthest outposts of the world and been abandoned by sailors visiting some of the remotest islands on earth.

It is the adaptability of the cat which is one of its virtues as a companion – and yet also one of its vices. It is never truly tame; within a generation or two, cats will revert back to shy, unapproachable creatures of the shadows, having never lost their survival instincts. This is why those left behind to survive on uninhabited islands were able to do so, often decimating the local wildlife as a result.

On the other hand, cats are certainly content to live alongside us in a wide range of different situations – from royal courts to inner city alleys – and they can serve almost as a mirror on society itself. Cats are now firmly established as part of our cultural heritage, and as society has changed, so has the way in which they are portrayed.

There was an overtly romantic view of cats that became fashionable in the second half of the Nineteenth Century. At this stage, kittens especially attracted the attention of artists who concentrated on capturing both their inquisitive natures and innocence. Such art is now often dismissed as representing a 'chocolate box' style – simply meaning that

its value is as decoration rather than having intrinsic artistic merit. In many ways though, this is still how we would want to perceive cats in our life, ignoring their hunting instincts, which cause them to maim and kill other creatures that they encounter. This naivety, in turn, ultimately gave rise to the art world's Catland movement, an imaginary world populated by cats carrying out human activities such as skating; and yet this also turned out to be a satire on society itself.

As different types of media – notably film, television and computer games – developed over the course of the last century, so portrayals of cats diversified too. Soon, they were being portrayed with human vices rather than clothing, reflecting characteristics such as greed, selfishness and sloth in their personalities. On the other hand, cats could be elegant and sophisticated too, quite apart from often possessing the intelligence to outwit a feeble mutt or even their owner on occasions.

In virtually all instances, there is still an affectionate bond evident in the relationships of cats and people, who may play just a relatively minor, supporting role in such dramas. This is probably unsurprising, given the fact that generally, cats are now more popular as pets than dogs. Most owners simply accept that a cat will take over their lives in a different way to a dog. A canine companion will seek affection, whereas its feline counterpart may or may not react accordingly to its owner. Cats are fundamentally unpredictable, but as many of the extraordinary real-life stories about cats covered in this book reveal, they can display remarkable loyalty towards people, which may often be just as strong as any forged by a dog, even under conditions of extreme adversity.

Having grown up and spent my life with both cats and dogs, I think it is simply a matter of acknowledging that they are different, in both character and outlook, rather than judging them. A relationship with a cat is multi-faceted and

can never be taken for granted. After all, even the most seemingly affectionate and devoted cat may be lured away by the siren call of more attractive food accessible in a neighbour's home! In addition, as a writer, I find the way in which real life experiences involving cats, and the fictional stories created about them, may have common themes that are quite fascinating. This does not just apply in the case of words, but in the case of images too.

Increasingly today, fictional cats are being portrayed as commentators on society and its failings. This may seem a new trend, but the basis for this movement dates back to the Catland era during the later years of the 1800s, and one of the founding fathers of the Cat Fancy, Louis Wain. He portrayed cats with human attributes, actively seeking out people in restaurants and other social situation whom he would transform into feline characters.

Wain's approach afforded a powerful opportunity for parody, although it was certainly not as barbed in style as others who would subsequently adopt this type of presentation. His work, largely out of fashion today for seemingly being rather unsophisticated, should be attracting greater interest for beginning this significant trend in social commentary. As a cat person himself, he understood the relationship that links people and cats, and how its parameters are defined, whether in fact or fiction.

Why Puss?

The legacy of this early era in the cat's domestication is reflected in the English language today. The affectionate term 'puss', often used for cats, is thought to be derived from the names given to the Egyptian cat goddess, who was variously known as 'Pasht' and 'Bubastis'

SECTION ONE

Cats in Art, Literature and Entertainment

CHAPTER 1

Cat Terms

THERE are a number of sayings related to cats in the English language. The origins of such phrases date back centuries in some cases, and although the original significance of the words themselves may have been lost, they have subsequently acquired new meanings and so are still widely-used in conversations today.

The description of 'cat' and other feline references such as 'pussy' have also been incorporated into individual words. These often reflect either aspects of a cat's appearance or its behaviour. In turn, the description of 'cat' may be applied to other creatures too, such as the grey catbird (*Dumetella carolinensis*) from North America and other similar species, whose calls are said to sound like cats miaowing. Catfish are so-called because of the whisker-like projections around their mouths.

There are various plants, too, whose names reflect links with cats. Catmint or catnip (*Nepeta cataria*) is a plant which many but not all cats find attractive, causing them to display obvious signs of pleasure. Catkins, which are the trailing flowers associated with a number of shrubs and trees, resemble a cat's tail in appearance in the spring when they are most conspicuous. There is also pussy willow (*Salix caprea*) – a shrub which may grow into a small tree and has soft, silvery catkins which feel rather like cat's fur, especially before they open.

However, it is worth bearing in mind that not every reference in the English language which seemingly relates to cats, actually refers to felines. An example in this case is

Some Feline Sayings

'Letting the cat out of the bag' – meaning revealing a surprise

An expression which dates back to the medieval period. It was not uncommon for young cats to be substituted in place of piglets, being sold in sacks to unwary purchasers.

'Raining cats and dogs' – meaning raining hard

This dates back to the days of the Great Plague which struck London in 1665. Cats, and dogs too, died as a result of the infection, with their corpses being washed through the streets in heavy rainstorms.

'Not enough room to swing a cat' – meaning a confined space

The earliest use of this saying dates back to 1771, being derived from the nautical use of the whip called the cat-o'-nine-tails on board a ship.

'Put the cat among the pigeons' – meaning introducing a new, controversial element to a discussion

This probably refers to the way that cats might be used to drive away domestic pigeons from nearby dovecotes which would steal food from the fields.

'Like a cat on a hot tin roof'- meaning in an agitated or worried state

A behavioural reference to the way in which a cat will move to avoid burning its paws, having minimal contact with the roof.

Some Feline Words

Cat burglar – someone who climbs up, to gain access to a building through an upper window, rather like a cat.

Catcall – shrill whistle, again similar to the calls of a female cat uttered when mating.

Caterwaul – screeching in an unpleasant way, rather like cats mating.

Catnap – sleeping for short periods, usually during the day, in a similar way to cats.

Cat's eyes – the glass reflectors set in roads which pick up the light of a car's headlamps after dark, allowing the driver to follow the course of the road safely. This equipment was so-called because of the way that the *tapidum lucidum*, which is the reflective layer at the back of the eyes also reflects back light after dark, causing the eyes to appear as if they are glowing.

Cat's whisker – this was the name given to the pointed wire which connected with the crystal in early radios, then called crystal sets. The plural form 'cat's whiskers' is often used to describe something that is superior.

Catty – unpleasant behaviour or a remark.

Having kittens – reacting in an agitated or nervous state.

Kittenish nature – flirtatious.

Pussyfoot – move warily, in the same way as a cat.

the word 'kitty', to describe a communal pot of money, as featured in poker and other card games. This particular word is thought to derive either from 'kit', meaning a set of articles – as typified by a soldier's kit – or is a corruption of the northern word 'kidcote', which meant a prison. There is nothing here to suggest a link with cats.

CHAPTER 2

Felines in Folk Tales and Fairy Stories

THERE is often a moral which forms an underlying theme in traditional tales of this type, based on the attributes of the creature in question, with independence of thought being something which tends to characterise cats. Stories of this type, which are still popular today, typically have ancient roots, including Puss-in-Boots which had already been passed down through many generations before the French academic Charles Perrault (1628–1703) decided to retell it, along with other folk tales, under the title *Stories or Tales from Times Past, with Morals*.

In the case of Puss-in-Boots, when a miller died, he left his property to his sons. His first son inherited the mill itself, while the second son received the donkey. The youngest son was upset to be given only a cat. But the cat could talk, and told him not to worry; he could make them both rich. But he needed a hat, cloak and boots for this purpose, plus a bag. Given what he required, the cat then disappeared. He went hunting, catching a rabbit which he left at the local castle as a gift for the king. This then continued over the course of many days, until people started to ask what triggered this act of generosity. The cat replied that it was from his master, the Marquis of Carabas. No-one knew the Marquis however, and one day, the queen summoned the cat, to enquire further about his master. The cat explained that the Marquis was wealthy and handsome, taking the opportunity to invite the king

and queen to visit him at his castle, with the invitation being readily accepted.

The miller's son was overcome with worry when the cat told him what had transpired, but it was all part of his plan. The royal entourage set off, but meanwhile, the cat arranged for his master to strip off his shabby clothes and go for a swim in the nearby river. As the royal coach drew close, the cat rushed across the road to halt the procession, explaining that his master was drowning. The king's servants dived into the river and rescued him, giving him new clothes to wear. The beautiful princess was transfixed by the supposed Marquis, who fell in love with her too, at first sight.

Before they could be married however, Puss-in-Boots needed to obtain a castle. Before he headed towards the castle where an ogre lived, he told local workers that they were to say the land was all owned by the Marquis of Carabas. The ogre could change appearance and became a roaring lion to frighten the cat. But then the cat told him that he had heard that he could not make himself smaller, suggesting the ogre should change himself in a rat or mouse. The ogre made the fatal mistake of doing so, allowing the cat to grab and eat the rodent before the royal party reached the castle. The marriage went ahead and thanks to the cat's resourcefulness, he made his owner not only a rich but also a very happy man with his new bride.

Dick Whittington and his Cat

Although now often portrayed as a fictional character, this popular story has a basis in fact – except that in real life, there was actually no cat involved! There was a Richard Whittington, the second son of a wealthy knight who lived the English county of Gloucestershire. On his father's death, Richard headed to London in search of work and became apprentice to a mercer who traded in precious

materials. He learnt the business and soon prospered himself. He became Lord Mayor of London for the first time in 1399, and continued in the post until his death in 1423. Richard Whittington bequeathed his considerable fortune to help the poor, with some of his money being used to build an almshouse.

Subsequently, different stories started to be told to explain his fortune. One is that Dick came up to London and lodged in the home of a wealthy merchant family, sharing his attic with a cat who is an excellent mouser. He has the chance to invest in an overseas voyage, but has no money, so he sends his cat along on the trip. The voyage is a tremendous success, and the king of a far-flung kingdom is so impressed by Dick's cat that he pays a fortune for the animal, making him a very rich man. He is able to marry his sweetheart Alice (the merchant's daughter) and become Lord Mayor of London.

CHAPTER 3

Cats in Literature

THERE are a number of famous writers who have been inspired by felines; often those which they have kept themselves as pets. Samuel Longhorn Clemens (1835–1910), who wrote under the pseudonym of Mark Twain, was a great ailurophile (cat lover). He chose very elaborate names for his own cats; these ranged across the full spectrum of the alphabet, from Apollinaris to Zoroaster. Clemens admitted choosing such names to encourage his children to learn how to pronounce unfamiliar words. Evidence suggests, however, that the cats too may have had difficulty in learning their names. They will respond better to short words, which incorporate long vowel sounds. Clemens did name two others with more simple names though – Buffalo Bill and Sour Mash.

The French novelist Colette (1873–1954), who is best-known today for her novel *Gigi*, was a highly controversial figure in many respects. Her affairs with men and women caused considerable scandal, but there is no doubt that cats played a central role throughout her life. They also featured quite prominently in her writing. There was *Sept Dialogues de Bêtes*, first published in 1913, which described the relationship between her Turkish Angora cat, called Kiki-la-Doucette and a French Bulldog called Toby.

She also wrote about the Chartreux which is a bluish-grey breed native to France and rarely seen elsewhere, even today. It was developed at the monastery of La Grande Chartreuse which lies to the north of Grenoble, in the south-east of the country. Colette's story, entitled *La Chatte*, told

19

the story of Saha, who was badly-mistreated by his owner's wife, causing the couple to split up. An English version of this story was published in 1936. But Colette's involvement with cats was not confined to domestic individuals. For a while, she had an African wild cat christened Ba-tou which featured in her work *La Maison de Claudine*, published in 1922. She described Ba-tou as being less secretive than domestic cats. In fact, his obvious predatory instincts meant that he finally had to be sent to a zoo, rather than remaining as a pet alongside the rest of Colette's menagerie.

Beatrix Potter, (1866–1943) had a keen interest in animals from early childhood and trained herself to draw them, taking her early inspiration from her pet rabbits. Although today she is best-known for *Peter Rabbit*, a number of cats featured in her stories as well. The earliest was Simpkin, who appeared in *The Tailor of Gloucester*, which was originally published in October 1903. It soon became a tradition for this to be read to children on Christmas Eve as the story takes place over Christmas. The tailor is very poor, living over his shop with his cat Simpkin and some mice. Simpkin is asked to buy some fine silk so the tailor can complete a fine wedding coat for the mayor, but is angry to find that his master has released the mice in his absence, so he hides the silk. The mice, however, work through the night and complete the coat for the tailor – except for one buttonhole because they run out of thread.

A more sympathetic portrayal of cats followed four years later, in *The Tale of Tom Kitten*. This introduced not just Tom, but also his littermates, Mittens and Moppet. They were always involved in mischief, much to the consternation of their mother, Tabitha Twitchit. She sends them out, imploring them to keep their new clothes clean, but then they end up in trouble and lose some of their clothes to some ducks. Full of shame, Tabitha has to hide her offspring away upstairs when visitors call, using the excuse they have measles.

A number of Beatrix Potter's characters reappear in more than one book such as Tom Kitten. In 1908, he was fighting for his life in *The Roly-Poly Pudding* after being caught by rats Mr. Samuel Whiskers and his wife Anna Maria, who decide to make the young kitten into a pudding. This story ultimately became better known as *The Tale of Samuel Whiskers* when it was republished in 1926.

Tom's sister Moppet featured in her own tale *The Story of Miss Moppet* when she fails to catch a mouse. Moppet wraps a duster around her head, and the mouse, intrigued by this behaviour, emerges from his hiding place and sneaks back to have a closer look, not realising that she can see him through a hole in the duster. This enables Moppet to pounce, catch the mouse and wrap him up in the duster, only to see him escape through the same hole.

The following year, *The Tale of Ginger and Pickles* was published. It featured Ginger, a tom cat, and his business partner, a terrier called Pickles, who unsuccessfully run a shop because they allow their customers to have too much credit. Tabitha Twitchit also appeared in the story, but this time, she ran a rival shop, increasing her prices once the other shop had gone out of business. In the end, it was reopened by a hen called Henny Penny.

Feline characters in Beatrix Potter's stories

Ginger – *The Tale of Ginger and Pickles*
Mittens – *The Tale of Tom Kitten*
Moppet – *The Tale of Tom Kitten/*
 The Story of Miss Moppet
Simpkin – *The Tailor of Gloucester*
Tabitha Twitchit – *The Tale of Tom Kitten/*
 The Tale of Ginger and Pickles
Tom – *The Tale of Tom Kitten/The Roly-Poly Pudding/*
 The Tale of Samuel Whiskers

The American writer Paul Gallico (1897–1976) wrote four quite different books about cats and their lives. These began with *Jennie* which was followed by *Thomasina: The Cat Who Thought She Was God*, published in 1957. Thomasina is a red tabby and the treasured pet of vet's daughter Mary Ruadh. Believing Thomasina to be dying, the vet puts her to sleep, but fails to administer the correct lethal dose of anaesthetic. Thomasina eventually wakes up and is saved by a woman called Lori. She is delusional however, believing herself to be the reincarnation of an Egyptian cat goddess. Meanwhile, her owner, overcome by grief, becomes suicidal. Luckily, Thomasina recovers from her experience and manages to find her way back home. This story was adapted by Walt Disney for the film *The Three Lives of Thomasina* which premiered in 1964 and starring actress Susan Hampshire as her owner. The tale then became so popular in the former USSR that it was remade under the title *Bezumyana Lori* in the 1990s.

Even more popular with cat-owners was Gallico's book *The Silent Miaow*, published in 1964 and subtitled 'A manual for kittens, strays and homeless cats'. Gallico claimed he translated this from cat talk and gave information about how to engage with and train a family. It was an illustrated work, with photographs taken by Suzanne Szasz. His final work about cats, *Honorable Cat*, then appeared in 1972, four years before his death. This was a book of poems about cats, with an extensive introduction and included over 70 striking colour photographs.

CHAPTER 4

Cats in Film, TV and on the Stage

HE WAY in which fictional cats are portrayed in these
media tends to be an extension of their characteristics
as reflected in earlier stories. Indeed, a number of the
traditional tales such as *Puss-in-Boots* (see page 16) have
been retold in these different ways. It has become a popular
pantomine, as well as a screen presentation. This has allowed
directors to develop anthropomorphic characteristics of cats,
to the extent that unlike dogs, they are often not portrayed
in a very positive light. Scheming, scamming and indolence
are just some of the features associated with more recent
fictional felines to have emerged on to our screens, as
typified by the cartoon character Top Cat (see page 201),
leader of a gang of street cats. Yet in the true mould of the
anti-hero, none is beyond redemption, which is probably
the essence of what makes them appealing to the viewer.

Alley cats are a recurring theme in cartoon stories, as
seen in *The Aristocats*, a Walt Disney film release in 1970.
Yet some cats, especially Siamese, are portrayed as elegant
and aloof by nature. This provides the contrast between the
wily alley cat and the rather naive pure-bred who has
enjoyed a sheltered existence until confronted by the real
world. In *The Aristocats*, these roles are assumed by Thomas
O'Malley, and Duchess, with her elegant, white-coated
appearance.

An earlier animated feature exploring a similar theme
was *Gay Purr-ee*, released in 1962. The story is set largely in

Paris where Mewsette, drawn here from Provence by the allure of the excitement of the city, meets Meowrice, a con-artist who wants to sell her to a wealthy husband in America. Luckily, she is rescued by friends from home just in time. What makes this film particularly notable today is the involvement of Judy Garland. She voiced the part of Mewsette in her only animated film role, and also suggested that the songs for *Gay Purr-ee* should be written by Harold Arlen and Edgar Harburg, who composed the music for *The Wizard of Oz*. The best-known composition from the film is probably 'Paris is a Lonely Town', sung by Mewsette as she walks the streets, disillusioned and alone. The soundtrack first became available as an LP record in 1962 and was subsequently re-released as a CD in 2003, featuring both the tracks from the film and the original demos of the songs performed by Arlen and Harburg.

Aside from creating personalities to enliven the characters drawn from our observations of cats, however, their natural behaviour has also been incorporated in these portrayals. Both their purring and sinuous forms have been used to great effect by animators in particular.

CHAPTER 5

Cat Actors

THE FIRST feline superstar of the cinema was discovered by chance. Director Mack Sennet, who created the Keystone Cops in the days of silent movies, was entranced when a stray bluish-grey cat appeared in a scene, having gained access to the set through a loose floorboard. When the actors walked off as the scene drew to a close, the cat followed them without any hesitation. Sennet realised the appeal to audiences of having a cat involved in some films and immediately adopted the stray, whom he christened Pepper. She went on to work with most of the leading stars of the cinema's early days, including Charlie Chaplin. Pepper's professionalism meant that her meeting with Frederich the Mouse passed without incident, and she struck up a very close relationship with Keystone Teddy, a great Dane, with whom she appeared in a number of films. After his death at the end of the 1920s, acting subsequently seemed to lose its appeal for her, and she retired soon afterwards.

In 1951, a red tabby called Orangey starred in the movie *Rhubarb* which told the story of a cat who had been left a fortune and a baseball team by an eccentric millionaire who took him in off the streets. He was then given a regular part in the television comedy series *Our Miss Brooks* and went on to star in a number of other films, including *The Incredible Shrinking Man* in 1957, although his most famous part was probably playing opposite Audrey Hepburn in *Breakfast at Tiffany's*, released during 1961. He won a second Patsy (Picture Animal Top Star of the Year) award for this

performance, to go alongside his previous one for his role in *Rhubarb*. Orangey remains the only cat to have scooped two of these awards, which are the animal equivalent of an Oscar. Orangey's last big screen appearance was in *Village of the Giants* in 1965, ending a career spanning 14 years in the film industry.

Another orange tabby called Milo came to prominence after starring with a fawn pug called Otis in a Japanese film, *Koneko Monogatari* (*A Kitten's Story*). This was released in 1986, but was then radically reworked to emerge three years later as an English version called *The Adventures of Milo and Otis*. Milo is rescued from drowning by Otis and the pair embark on a series of adventures together. Shooting the film was a mammoth undertaking which took four years, and the final cut was assembled from nearly 76 miles (122 km) of footage.

One of the reasons cats are not so recognised as stars in the film world as dogs or horses is the difficulty in training them to carry out specific roles. Producer and director Armado Acosta faced this problem with *Romeo-Juliet*, a highly creative film based on Shakespeare's play, which was released in 1990, and ended up with a highly complex editing job. The actors in this case were largely a group of feral cats living in New York, Venice and Ghent; their voices provided by various leading contemporary actors. The basic plot of the film was an eccentric lady (played by actor John Hurt} who decides to sail from the port of Venice to the New World with an eclectic range of stray cats.

Over recent years, many cat videos have appeared on the Internet, but only one real star emerged from them all. His name was Frank, and he lived in Cambridge with his owner David Donna. Frank was left with a broken pelvis after a car accident in 2002, and knowing this would mean a long period of recuperation indoors, David decided to test some software and set up a website allowing surfers to monitor Frank's progress, complete with three webcams.

Then, the site was revolutionary and it attracted two thousand hits within five minutes of launching. By the time Frank recovered, more than five million people world-wide had logged on to check on his progress. This included the anonymous local couple who had helped Frank immediately after he had been hit by the vehicle, arranging the veterinary care which ultimately saved his life. They contacted David, having seen Frank on the web, and were able to monitor his progress at first hand.

Cats in Musicals

BY FAR the most famous and successful musical production on a feline theme is the West End show *Cats* which opened on May 11th 1981 at the New London Theatre in London. It has since been seen in more than 250 cities in over 20 countries. Interestingly, although the words themselves are usually translated from English, the title itself is rarely changed. Sir Andrew Lloyd Webber was inspired by T.S. Eliot's famous poem, *Old Possum's Book of Practical Cats*, which he remembered fondly from his childhood. He began adapting the verse to music in 1977, with the idea of creating a concert which could be shown on television. Some of the early pieces were tried out at the 1980 Sydmonton Festival at Lloyd Webber's home estate. Among the guests was Valerie Eliot, who gave the composer some further unpublished verses, including a poem written by Eliot (1888–1965) entitled *Grizabella the Glamour Cat*.

This additional material represented just part of what Eliot penned, so Lloyd Webber sought a collaborator who could adapt the words to create a stage show. In the late summer of 1980, he started working on the idea with theatre director Trevor Nunn. They created the tribe called the Jellicle cats, whose haunt is a junkyard. Each of the cats has three names – a relatively formal one, one that is used by their fellow cats every day, plus a third secret name.

The list of cats is longer in the stage production than in T.S. Eliot's poem, reflecting adjustments such as the inclusion of Grizabella, who existence was not revealed in

the original work (See also *Old Possum's Book of Practical Cats* in the A-Z). In spite of a disastrous first night when the theatre had to be evacuated because of a bomb threat, *Cats* went on to celebrate 21 years on the London stage, finally closing in 2002 after some 9000 performances. Many of the original cast went on to star in a wide range of other acclaimed stage, television and film productions. They include singers Elaine Paige and Sarah Brightman, actor Brian Blessed and actor/singer Paul Nicholas. The show has been seen by an estimated 50 million people worldwide, ran for 18 years on Broadway and various productions are still touring.

List of the Jellicle Cats featuring in the musical

Admetus – replaces Plato in some versions of the stage show. He is a younger Jellicle.

Alonzo – one of the young cats with a responsible attitude who forms a close bond with Munkustrap. Tends to be black and white in colour.

Asparagus – effectively one of the older cats in the background. A younger version of Gus.

Bombalurina – works with Demeter, on behalf of Macavity.

Bustopher Jones – a black cat who always wears white spats and enjoys the good things in life, such as fine dining. Described as the 'Twenty-five Pounder' on account of his weight.

Carbucketty – probably the youngest of the cats. but replaced by 'Pouncival' in US productions. Eliot particularly liked the original name, considering it ideal for a cat. Not often seen in contemporary productions.

Cassandra – belonging to the Abyssinian breed and a rather mysterious member of the cast with a braided tail.

Coricopat – Tantomile's male twin.

Demeter – one of Macavity's henchmen, along with Bombalurina.

Electra – a tabby friend of Etcetera.

Etcetera – another young tabby, who, like Electra is very attached to Rum Tum Tugger.

Exotica – originally only seen in the film role created specially for the British actress and dancer Femi Taylor, but who subsequently appeared in some stage versions too.

Genghis – a Siamese who plots Growltiger's demise. Also known as Gilbert, and sometimes as Dschinghis.

George – a young tom who appeared in the London production.

Gilbert – another name for Genghis, although he is a separate character in the Japanese version of the play.

Griddlebone – a white female Persian cat whose suitor was Growltiger.

Grizabella – a glamorous cat who made the mistake of leaving the group and is thus perceived as an outsider.

Growltiger – a theatrical character living on a barge.

Gus – an older version of Asparagus and who has become a famous actor.

Jellylorum – named after Eliot's own cat, she has a kindly nature, mothering the kittens and ensuring they do not get into trouble.

Jemima – one of the younger kittens and in the group who adores Rum Tum Tugger. Her role was substituted by Sillabub in the Broadway production.

Jennyanydots – an older cat who spends her time sitting around or sleeping. She is called 'Old Gumbie Cat', when not watching over the younger ones.

Macavity – the villain of the piece, but who always seems to be able to conjure up an alibi. He is often known as the 'Napoleon of Crime'.

Mr. Mistoffelees – described as the conjuring cat with magical powers.

Mungojerrie – a practical joker, full of fun, who causes chaos with Rumpleteazer.

Munkustrap – a large, blue tabby who sets the scene, explaining how the Jellicle cats meet annually.

Old Deuteronomy – as his name suggests, he is the wise old member of the group and decides which of the cats will be reborn.

Plato – a young male cat and the dance partner of Victoria during the ball.

Pouncival – generally regarded as the youngest member of the group. Replaced by Carbucketty in British stage versions.

Quaxo – one of the minor characters who helps to set the scene for the ball.

Rumpleteazer – spelt Rumpelteazer by T.S. Eliot. He is a close friend of Mungojerrie. The pair leap around together and are often responsible for objects being knocked over and broken.

Rumpus Cat – A rather wild individual with red eyes and a spikey coat. He presents something of a superhero, but is not included in productions which do not feature the song 'The Awefull Battle of the Pekes and Pollicles'.

Rum Tum Tugger – one of the young cats, who is both a prankster and a flirt.

Sillabub – a replacement for Jemima in the Broadway production.

Skimbleshanks – called The Railway Cat, because of his habit of riding trains. He is one of the older cats, acting as a favourite uncle.

Tantomile – Coricopat's female twin.

Tumblebrutus – a young brown and white cat and another of the minor characters.

Victor – a young blue cat, mainly associated with the London production.

Victoria – the young white cat who opens the show by dancing to signify the start of the ball.

CHAPTER 7

Theatre Felines

THERE has been a long tradition of cats in theatres, not just to control vermin, but also to help actors overcome their first-night nerves. Another reason for their permitted presence is that cats are believed to bring good luck – very important to a notoriously superstitious profession. It was actually taken as a sign of great fortune for the production if a cat messed in an actor's dressing room.

The involvement with cats in the theatre is believed to extend back before Shakespeare. In those early days, retired sailors often worked as stagehands as they were used to climbing, and tying up scenery presented them with few difficulties. They might bring a cat along with them.

One of the most famous theatre cats of recent times was Beerbohm. He was the principal mouser at the Globe Theatre (now known as the Gielgud) after moving there as a young cat in the mid-1970s. Beerbohm came from a lineage of theatre cats, being born at Her Majesty's Theatre nearby and named after the then actor-manager there, Herbert Beerbohm Tree. On occasions, Beerbohm chose to wander across the stage in the middle of a production, always upstaging the stars. He became very friendly with Fleur, another theatre cat who was based at the neighbouring Lyric Theatre.

In spite of being almost fatally injured in a road accident in this busy part of the capital, Beerbohm survived and lived for nearly 20 years. He died in 1995 having spent his retirement in Kent with one of the theatre's carpenters. Beerhohm remains the only cat to have had an obituary

published on the front page of the theatre newspaper *The Stage*, and his portrait still hangs in the theatre itself.

There was some trouble at the Theatre Royal in Drury Lane however, when a black and white cat called Ambrose arrived in 1974. He would persist in walking across the stage during the play *Billy*, starring Michael Crawford, provoking mirth amongst the audience, but reportedly causing great annoyance to the star. Nevertheless, Ambrose was allowed to stay and Avis Bunnage, an actress in the production, became captivated by him. She regularly kept in touch with the theatre, to find out how Ambrose was and when he fell ill in 1983, she helped to pay the veterinary costs for his treatment. Ambrose passed away two years later, and has not been replaced.

Today, there are sadly very few theatre cats left, either in London or in the provinces. The Oxford Playhouse retired its cat, known as BC (an abbreviation for *Big Cat*) in 1996, much to anger of some of the staff. At least one theatre still acknowledges the tradition though, because although the last working cat resided at the Theatre Royal in Bath back in the 1970s, a stuffed cat is still kept on the premises.

The best-known theatre cats today are probably Jack and Cleo, whose stage names are Brutus and Portia. They are resident at Shakespeare's Globe, attracting considerable attention and publicity. The Comedy Theatre on Panton Street, Westminster has also kept the theatre cat tradition alive, at least front of house, with Vivian, named after Vivian Leigh and Marilyn, so-called after Marilyn Monroe being seen there. The unforeseen risks of allowing cats to roam freely in theatres were shown by the aptly-named duo of Boy Cat and Girl Cat when Princess Margaret (1930–2002) came to visit The Albery theatre in St. Martin's Lane and Boy Cat ate her bouquet.

CHAPTER 8

Architectural Cats

THE ELEGANT shape of cats has provided inspiration for some architects and is reflected in the design of certain buildings. One of the best-known examples of recent times is the slit-like roof detail, representing the appearance of a cat's eyes, seen on top of a high-rise building on Singapore's Amoy Street, looking down over the central district of Outram. This design seems particularly appropriate in this setting, given that the city itself is home to the Singapura breed, which evolved on the streets there. Even so, names can be confusing. For example, despite its name, the CAT Building overlooking Bangkok's Chao Praya River is not linked with cats, either in its design or origins. This is simply an acronym for the Communications Authority of Thailand.

There is, however, no mistaking the Cat House (Kaíu mâja) in the centre of Riga, the capital city of the Baltic state of Latvia. Located in a prominent position, it displays two black cats on the points of each of its towers. They were intended as an insult, an act which had tragic consequences. Involved in a dispute with local politicians, the original owner of the house had the cats placed with their rear ends pointing across the road in the direction of his opponents. Sadly, the sculptor who made the cats fell to his death while putting them in position.

Other representations of cats linked with buildings can be seen elsewhere in the world, such as the Black Cat at Greater London House in London's Hampstead Road. Its origins can be traced back to the 1820s, when a Spanish

nobleman called Don Jose Carreras Ferrer started in business selling cigars. The logo of the Carreras company was a black cat, inspired by the discovery of Tutankhamen's tomb in 1920. The building was designed with two striking bronze cats measuring over 7 ft (213 cm) tall in an Egyptian style, each side of the steps leading up to the main entrance. There are also ten other smaller black cats incorporated into the design of the building itself. The building was ultimately sold to developers in 1959 and transformed into what became known as Greater London House. It was to be a further 40 years before it was restored to its original splendour as an icon of the art deco movement.

There is even a case of a house being designed by architects for a cat. When Edward Lear was planning a new home, it is said that he instructed them to ensure it matched his old house, so that his pet Foss would settle down easily in what would otherwise have been unfamiliar surroundings.

Cats in Art

THE LARGEST public collection of cat art in all its forms from around the world can be found at Malaysia's Kuching Cat Museum in the Petra Jaya area of the city. The idea for the museum came from Sarawak's then Chief Minister, YAB Datuk Patinggi Tan Sri Hj Abdul Taib Mahmud and his wife. It opened in 1993 and there are more than 2000 exhibits on display, including the kitsch and cute, as well as a collection of stamps featuring cats.

Kuching itself is the old Malay word for 'cat', which may explain the city's name. Alternatively, it could be linked to the 'mata kucing', also called the cat's eye fruit, which used to grow alongside the river in what is now the centre of the city. Better known in Chinese as the 'longan' or 'dragon's eye', the fruit looks like eyeballs, with the small dark seed at the centre being visible through the semi-transparent fruit.

It was not until the 1800s that artists began to specialise in portraying cats. Louis Wain (1860–1939) played a key role in this movement. Trained at the West London School of Art, Wain began his career portraying animals for journals of the period, such as the *Illustrated London News*. His interest in cats began under tragic circumstances when his beloved wife was confined to bed with cancer, just three years after they married in 1883. Wain acquired a young kitten called Peter for his bedridden wife and sketched the pet while she played with it. He taught him tricks too, such as wearing glasses and apparently reading the newspaper, to try to amuse his wife.

The first of Louis Wain's drawings, *A Kittens' Christmas Party*, appeared in 1886. Although some of the cats were playing games, there was none of the anthropomorphism that was to define his later work. He admitted later that he would go and sketch people in public places, interpreting them as cats, with the resulting works often being very humorous. The cat pictures gradually evolved from individuals which clearly represented the feline form and were equipped with perhaps just a scarf, to cats in human poses who were fully dressed – even wearing ice skates in some cases. This was a human world populated by cats. The Catland movement boomed partly in response to the growth in popularity of the picture postcard, with Wain's scenes ideal for this purpose, raising a smile for both the sender and the recipient. However, the idea later lost its popularity, just as the naive idealism that accompanied those signing-up at the outbreak of the First World War was replaced by a worn-weary acknowledgement of the horrors of the conflict. Times had changed, and so had the public's outlook.

Wain took his responsibilities towards cats very seriously, wanting to overcome the prejudice that he felt still existed towards cats in Victorian Britain. He assisted welfare groups concerned with the animal and served in various roles on the committee of the National Cat Club which promoted the showing of cats. Sadly however, as Wain grew older, his mental health began to deteriorate and he was eventually committed to an asylum. Nevertheless, he was still able to use his artistic skill to portray cats right up until the end of his life, although in the latter years, the images themselves were generally far more abstract.

CHAPTER 10

Cats in Advertising

IT IS QUITE remarkable how brand dynasties have become established, driven by television appearances of individual cats. The star of the most famous British advertisements of this type was Arthur. He was a white, shorthaired cat, with the trademark ability to feed himself by dipping his paw into a can of cat food, in a very elegant manner. Spillers, the pet food company, reputedly purchased him for the sum of £700, but then came a bitter custody battle with his original owner, who claimed this was not actually the case. Arthur mysteriously disappeared on the morning the case was set to be heard in the High Court in London.

This led to the cat's former owner being jailed for two weeks for contempt of court, but suddenly, after the man had served just a day of his sentence, Arthur reappeared. The legal battle lasted for two years and was finally resolved in Spillers' favour. Arthur's career, which began during 1966, saw him appear in over 300 commercials over the course of nearly a decade. His image was emblazoned on cans of cat food and there was even a ghosted auto-biography of Arthur published, along with T-shirts and other merchandising. He was almost 17 years old when he passed away in February 1976.

It was a decade later before the Arthur campaign was revived, this time using a sick stray who had been handed into an animal sanctuary. 'Arthur II' was nursed back to health and introduced to the press in the august surroundings of London's Savoy Hotel in January 1987. He had the

ability displayed by his predecessor to eat with his paw but never quite managed to match his notoriety, and retired after nine years in the spotlight. Although other cats have been used to front successful advertising campaigns for cat food since then, these have been focused on breeds such as the British Blue, rather than individual cats.

A very similar sequence of events occurred at roughly the same time in the United States. During 1968, an animal trainer called Bob Martwick rescued a big stray ginger tom cat who was just minutes away from being euthanised at an animal shelter. Christened 'Lucky', he was thought to be about seven years old and had a very steady temperament. His big break came the following year, when Martwick took him to an audition for a cat to front a television advertising campaign for cat food.

Renamed Morris, he had a reputation for only enjoying the finer things in life, and this extended to his food as well. Morris rapidly became a star in his own right, mixing with the leading Hollywood personalities of the day, and even starring in the movie *Shamus* alongside Burt Reynolds and Dyan Cannon. This role won him a Patsy (see page 25), and he continued to travel by limousine and to be seen at fashionable eateries in the company of young female felines. Morris even visited the White House. His rags-to-riches biography was published in 1974 after he had been voted the *World's Most Famous Cat* the previous year.

By the time Morris passed away in 1978, he had appeared in some 40 commercials during his nine-year career and had built up a massive following. Finding his successor was not an easy task. It took the best part of two-and-a-half years. Morris II was also found in a rescue centre, and was so similar in appearance to his predecessor that it was hard to tell them apart. He appeared to be more interested in a political career however, becoming briefly a candidate to contest the Presidency of the United States in 1988.

At the launch of his campaign at a press conference in Washington DC, he was regarded as having a higher profile than any of the other candidates, including having had a biography published. Although unsuccessful, this period was not a catastrophe for Morris II. He boosted his reputation further during his brief foray on the campaign trail, as he did again at the 1992 election, standing once more under the banner of the Finicky Party.

When Morris II retired from the scene, Morris III took on the role, starring in a new advertising campaign that began in October 1995. Within two years, Morris III had visited virtually all 50 US states, flying first class around the country. This marked a major turnaround in his fortunes, as he had been found without a home in a Chicago animal shelter. His origins had him fronting a campaign in 2006 which was aimed at finding homes for a million cats abandoned in rescue shelters nationwide. Incredibly this was achieved by June 2008. Morris himself led the way, taking on responsibility for a kitten called Li'l Mo.

One of the strongest brand images in the US pet industry today is *Meow Mix*. This cat food name is spelt out in the image of a cat, but it is the advertising jingle which has helped to establish the brand over the past 35 years or so in the nation's consciousness. Written by Shelly Palmer, the tune has been 'sung' by a variety of cats asking for this particular food. It has even been featured in *The Simpsons* cartoon show.

In 2006, *Meow Mix* created a television series, based on the format of 'reality' show *Survivor* and featuring cats rescued from animal shelters across the United States. Over the course of 10 weeks, viewers and a panel of judges voted on which cat they wanted to assume a corporate role within the cat food company. Those cats which were voted off the show each week went to new homes. The programme was broadcast in three minute episodes each

week, but viewers could also watch the cats at home 24–7 on a computer, thanks to the webcam in their quarters.

Cat imagery has also been used to sell a host of other products, quite apart from pet food. Some of the most effective brand images in this field relate to wild rather than domestic cats, however, as typified by Jaguar Cars. Formed in 1945, the company has a very distinctive mascot of a jumping jaguar, suggesting power, speed and elegance. Having evolved as a luxury brand in the British car market, Jaguar has been sold on, firstly to the Ford Motor Company in 1989, although production has continued in the UK.

GM Holden Ltd, the Australian car manufacturer which is now part of the General Motors group, uses a lion as its motif. This dates back to the earliest days of the company in 1928, when it was described as the *Holden Lion and Stone*, thanks to the way in which the lion is sitting and touching a large round stone with its paws. The original designer of the logo, British-born sculptor Rayner Hoff (1894–1937), was inspired by the legendary tale of how watching lions rolling stones with their paws had inspired people to create wheels. The logo has been updated over 80 years, firstly in 1948, then again in 1972 and 1994.

It is not just cars that were linked with wild cats, but petrol too, with the launch of Esso's *Put a Tiger in your Tank* advertising in 1964. A similar campaign was run by Esso's US parent company, Enco (later Exxon) through North America, which again caught the public's imagination. The link between petroleum and tigers may seem tenuous, but it was the way in which advertisements showed the tiger start to run and accelerate smoothly which captured the message for motorists.

A friendly cartoon tiger has been used to sell Kellogg's sugar frosted corn flakes for over 50 years. Back in 1952 however, 'Tony the Tiger' was only one of the figures under consideration to become the brand image, facing competition from Newt the Gnu and Elmo the Elephant.

Tony's profile has altered considerably down through the years. In the early days, when created by the children's book illustrator Martin Provensen, he was much bigger, but has now evolved into a slim, athletic figure. For much of this time, voice actor Thurl Ravenscroft provided the deep bass rendering of the catchphrase 'They're Grreat' but since his death in 2005, professional wrestling announcer Lee Marshall has taken over.

A cartoon cat character called Felix has been used to promote the brand of cat food which carries his name in an on-going series of British television advertisements. But generally, pet food companies seem to prefer to have a real cat to promote their products.

SECTION TWO

Cats in Myths and Legends

CHAPTER 1

Cats in Legends

THERE are a number of legendary cats which feature in folklore tales from around the world. In Norse legend, Freya, the beautiful goddess of sexuality and fertility, travelled the heavens in a golden chariot pulled by two large cats, said to resemble the Norwegian Forest Cat, which is a very ancient breed from this area. Freya's cats were friendly by nature, but could react aggressively if aroused.

It was ultimately because of this link that cats became so heavily persecuted across Europe during the Fifteenth Century. At the same time, the followers of Freya were closely associated with cats in Germany where the cult was revived. When the authorities clamped down on the sect, following a papal edict, cats too were destined to be persecuted – a state of affairs which spread and lasted over the course of around 300 years.

Another mythical cat of Scandinavian origins was the Butter Cat, known in Finland simply as Para. Since cats relished cream, it was assumed they would bring gifts of butter in return, which explains the name of this mythical cat.

CHAPTER 2

Cat Gods

THERE was a time, right at the start of the domestication process, when cats had a vital role in saving people from starvation. The fertile Nile Valley was a very important agricultural area at that stage, supplying Egypt's growing population with grain and other similar foodstuffs. This concentration of food attracted plagues of mice and rats, which multiplied very rapidly. In turn, this drew African wild cats (*Felis lybica*) to the vicinity of the grain stores to prey on the rodents. Their presence was appreciated and encouraged by the people there, with the result that successive generations of these cats became progressively tamer. By the second millennium BC, the cat had clearly become fully domesticated, as can be seen from portrayals of cats in homely settings, behaving just like they do today, sitting under chairs for example.

Before long, this affection for cats spread more widely through the general population and so not surprisingly, by 450 BC, cats were regarded as being sacred. Affection for them within Egyptian society had also grown, to the extent that when a pet cat died, its family would shave their eyebrows as a mark of respect. The centre for this cult was the city of Bubastis (close to the contemporary city of Zagazig) where the oracle of Bast – a feline goddess – was located. There was an annual festival, which, according to the Greek writer Herodotus, drew up to 700,000 pilgrims with much feasting, drinking and fornication taking place.

Bast was seemingly a protector, portrayed initially as a lion, but she gradually evolved into a smaller, domestic cat,

47

with a decidedly feminine nature. She may in some ways have represented a more general fertility cult, linked with the sun. The lasting legacy of Bast is the way in which cats are still often portrayed as sensual creatures even today. There are also various references to Bast in fictional stories, including Wonder Woman, published by DC Comics, where a cat goddess of this name is worshipped by the Amazons of the fictional nation Bana-Mighdall, in Egypt.

CHAPTER 3

Cats in Heraldry

THERE are actually very few domestic cats featured in heraldry. This is a reflection of the fact that for much of the medieval period and beyond, they were not recognised as heroic symbols, but rather, as agents of the devil. Even before this however, domestic cats were not perceived in a heraldic role, in contrast to their wild cats, notably the lion, which was regarded as a symbol of strength and bravery. But cat sables on armorial bearings were carried by the Vandals and the Suevi tribe too. St. Clotilda (470–545 AD), daughter of Chilperic, King of Burgundy, has a similar arrangement, with the cat poised to catch a rat. The Venetian printer, Melchior Sessa developed the emblem of a cat with a rat actually in its jaws in the 1500s, while the shield of the Katzen family portrays a cat carrying a mouse in its mouth. St. Ives, the patron of lawyers, is portrayed with a cat, which is therefore regarded as representing the officials of justice. In more recent times, cats have featured on the patch of the three degree 'Stormo' of the Italian Air Force, with the heads of two black cats being present on a white background, and reversed out below.

CHAPTER 4

Mystical Cats

WITHIN the Scottish highlands there is reputed to be a mystical domestic cat called Cait Sith. It now appears to have a basis in fact. Such cats are larger than a normal domestic cat and black in colour, with a white area under the chin. Although originally the Cait Sith was believed to be a witch in disguise, it now seems most likely that accounts of such animals are simply a description of what is today known as the Kellas Cat. These cats represent a natural hybrid of this colour resulting from cross-breeding between Scottish wild cats and domestic cats.

CHAPTER 5

Cat Signs

INNS AND public houses in Britain traditionally advertised their presence by choosing memorable names with a colourful board bearing their chosen name hanging over the entrance. As in the case of heraldry however (see page 49), cats did not feature prominently from the medieval era through until the more enlightened thinking of the Restoration period from the 1660s onwards. This was because of fears linking cats with the devil.

Many of the earliest names were derivations based on what today would be known as the Cat and Fiddle. Ironically, this may not be anything to do with a cat! It may represent a corruption of the French phrase 'Caton Le Fidèle', meaning literally 'The Faithful Knight', with the description of 'Caton' in the Thirteenth Century being given to an English knight who had fought at Calais. Another possibility is that the name may have originated from the game of 'tipcat', which was played to an accompaniment of fiddles.

One of the oldest examples of a tavern of this name is thought to be 'Le Catt Cum Le Fiddle', in Bucklersbury, east London, which was trading back in 1501. It was later given the more anglicised name of 'The Catte and the Fiddle' in 1536. There was also a 'Catt and Fiddle' in London's famous Fleet Street, which opened around 1568, and another tavern of the same name in St. Lucknors Lane. The use of the older English word 'Catt' and its more modern derivative 'Cat', is apparent in various London inns with these names being used from the mid-1600s.

51

Another theme which emerged in the capital from this period was the naming of taverns after Dick Whittington and his cat (see page 17). The earliest of these opened for business in 1657 and was probably located at Long Lane in the West Smithfield area of London.

This long tradition is maintained today, with pubs with similar names found over a much wider area, from Whitehaven in the north-west of England across to the east coast port of Hull.

- Nursery Rhyme: A variation on the well-known rhyme, *Hey Diddle Diddle* featuring the cat and the fiddle, is believed to be a satirical rhyme describing the relationship between Queen Elizabeth I and her lover, Robert Dudley, the earl of Leicester. Another, completely different suggestion, is that it provides clues to what can be seen in the night sky, with the characters representing constellations, and the cat symbolising Leo – the Latin word for lion.

- Another feline theme in the naming of hostelries was 'Salutation and Cat', with premises of this name opening in Newgate Street, London, in 1744. It originated from the story that when Mary was told by the Archangel Gabriel she was to give birth to Christ, there was a cat present.

- A tavern called the 'Cat and Bagpipes' was open for business from 1810 until 1826, on the corner of Downing Street in London. This name – also adopted by a public house in Moate, Ireland – is thought to have been based on a nursery rhyme. It lives on in contemporary public houses, including one in the Yorkshire village of Northallerton – although there are those who believe this description may reflect an old cavalry term, with bagpipes being played as a warning of border raids.

Cat Signs

- The use of cats in pub names has increased significantly over recent years. Some, such as 'The Ginger Tom or 'The Black Cat', simply describe cats in general, but there are certain pubs with names which are specifically linked to their residents, although the underlying explanation may be less obvious. 'The Squinting Cat' in the Yorkshire spa town of Harrogate is named after a former landlady, who peeped out from behind a set of curtains to scrunitise customers, just like a cat!
- Probably the only pub in Britain which commemorates an actual breed is 'The Burmese Cat' in Melton Mowbray, Leicestershire, simply named because the wife of the brewery's chairman bred these cats.

CHAPTER 6

Black and White Cats

THERE have been a number of fables about white cats, dating back to Aesop (620–560 BC). This particular story is rather unusual however, because it involves the cat being turned by Venus, the goddess of love, into a beautiful princess. It allows her to be with her prince, but unfortunately, she betrays herself to him by chasing after a rat which scampers over the bedroom floor. A later French fairytale, written by the Comtesse D'Aulnoy (1650–1705) in 1682, is a variation on the theme of love and trust. In this case, a prince falls in love with a white cat and asks her to marry him. She tells him that to do so, he must cut off both her head and tail, throwing them on to the fire. He reluctantly carries out her wish, and in so doing, breaks the spell, transforming the cat back into a beautiful princess. This story is probably based on 'The Frog Princess', with the frog being replaced by a cat. It is a common theme which occurs in the folklore of a range of countries, including Russia, Germany and Italy.

There are contrasting superstitions surrounding black cats. They are believed to be lucky in some areas and situations, but not in others. This may reflect their perceived links with the Devil, while in some cases it simply arises as a result of their supposed magical powers which may be used for good.

CHAPTER 7

Lucky Cats

THE BECKONING cat is regarded as a long-standing symbol of good luck in Japanese culture, often being referred to as 'Maneki-neko'. Representations of this vary greatly, but they can all be identified by their raised paw. The origins of this belief may be traced back over 1,000 years or more, to the introductions of the first cats to Japan, almost certainly from China. Originally, cats could only be kept by the nobility but during the 1600s attitudes changed dramatically at a time when the country risked being overrun with a plague of rodents. Nothing was safe, as these pests would destroy all the official records carefully set down on rice paper, as well as plundering and contaminating food stores. The rapid increase in the number of Japanese Bobtail cats at this stage helped to contain the rodent population. As its name suggests, this unique and ancient Japanese breed has a short tail, resembling a bob. Part of the reason for their popularity may be linked with the belief that cats with full-length tails could change into witches. The coloration of these cats is distinctive. They tend to be predominantly white with black and red patches on their bodies and are described as the 'Mi-Ke'. The way in which Japanese Bobtails often sit with a paw raised is highly suggestive of the beckoning cat.

There are various stories to explain just how these cats acquired their lucky reputation. It may date back to the early days when cats were first seen in Japan at the temple of Gotokuji, which now forms part of the western outskirts of Tokyo. The monks living there used to be very poor, but

they always shared their food, ensuring their pet cat never went hungry. One day, a group of Samurai were riding along the road when the cat beckoned to them, drawing them into the temple. There was a torrential storm and just as they followed the cat, a bolt of lightening struck the ground where they had just been. The cat had saved them from certain death. The Samurai stayed for some time, and one of the warriors returned regularly and bequeathed his fortune to the temple.

A completely separate story about the beckoning cat relates to a woman living in Yoshiwara. A venomous snake was poised to strike at her and seeing the danger, her favourite cat jumped in between them, sustaining a fatal bite. In memory of her pet's bravery, she had its image carved in wood. Before long, such carvings were considered to be lucky charms, as word of what had happened spread further afield.

SECTION THREE

Royal and Political Cats

CHAPTER 1

Queenly Cats and Kingly Toms

CATS HAVE actually held very little appeal to royalty down through the centuries. They have greatly preferred canine companionship. This may be reflection of the fact that whereas dogs served a purpose in the royal courts, cats were deemed to be of little value in such surroundings. However, there was a brief period in the Sixteenth Century when cats did attract attention from the ladies of the court. It was at this stage that the ancestors of today's Persian cats, with their long, flowing coats were first seen in Europe. They probably originated from Turkey and were highly sought after on account of their pure white coats.

Among those who owned such cats was Marie Antoinette (1755–1793) of France, who was executed during the turmoil of the French Revolution. Legend suggests that some of these cats may have been smuggled out of France to America where they played a role in the creation of the Maine Coon breed, although there is no actual evidence to support this story.

In Britain, the only monarch who is known for a love of cats was Queen Victoria, although her affection for dogs was seemingly much greater. Nevertheless, she did like the Persian breed, and her interest in such cats at the end of her reign helped to ensure their popularity at a time when the creation of pedigree bloodlines of cats was just beginning.

CHAPTER 2

Political Pussies

PERHAPS not surprisingly, cats have managed to win round cynical politicians – but not everything is always what it seems. There were many visitors to the White House who thought that Thomas Jefferson (1743–1826), the third man to hold the office of US President, had a cat. He actually had a mockingbird who could mimic the sound of a cat very convincingly!

Up to the time of writing, at least ten of America's forty-three Presidents are known to have kept cats during their period in office. These included Abraham Lincoln's cat Tabby. Lincoln was the sixteenth President, in office from 1861–1865. Like the majority of cats who have been resident at the White House, Tabby was an ordinary cat, without any obvious pure-bred past.

Ranking amongst the most devoted presidential cat-owners was Calvin Coolidge, who had five cats during his period at this prestigious Pennsylvania Avenue address in the 1920s. Their names were again essentially influenced by their appearance – Smokey, Blackie and Tiger. A particular favourite, Tiger was a tabby cat who allowed himself to be carried draped around the President's shoulders. On one occasion when Tiger disappeared, President Coolidge broadcast an appeal for the safe return of his beloved pet on the then relatively new medium of the radio. Tiger turned up about a mile away, after which the President then fitted his pets with collars. These incorporated an engraved plate, showing their home address as the White House. Sadly, this did not help Tiger however, because he soon strayed off once more and was never seen again.

Other feline residents included Bounder and Climber, whom Coolidge affectionately referred to as 'Mud'. Climber was actually a Turkish Angora cat, and the last feline resident to join President Coolidge in the White House. It was said that he died of a broken heart when the President retired to Massachusetts, leaving him behind. Coolidge himself was said not to be impressed by Climber's illustrious pure-bred origins, preferring ordinary felines.

Cats have become increasingly popular as companions amongst those living in the White House over recent years. From Gerald Ford who became President in 1974 up to George W. Bush who left office in 2009, five of the six Presidents during this period, (with the sole exception of George Bush's father), have shared their lives with cats. Ronald Reagan had two tortoiseshell strays, called Cleo and Sara, while Bill Clinton's black and white family cat was given the less conventional name of Socks. This was on account of the white areas on the feet.

Socks became embroiled in a long-standing feud which captured the attention of America, when the Clintons acquired a Labrador Retriever called Buddy. Things were so bad that when Bill Clinton left office in 2001, Socks was passed into the care of his secretary Betty Currie, rather than continuing to live alongside Buddy, whose life was then cut tragically short after being hit by a car. During his time with the Clintons however, Socks had the distinction of appearing with President Clinton on a set of stamps issued by the Central African Republic and his cartoon image was used in the White House to mark the route for schoolchildren visiting the building.

Aside from Coolidge's Climber, the only pure-bred cats to have lived at the White House have all been Siamese. During the 1970s, Susan, the daughter of President Gerald Ford, had a Siamese cat called Shan Shein. Then Jimmy Carter's daughter Amy kept another Siamese which rejoiced under the name of Misty Marlarky Ying Yang, at the

White House. It was back in 1878 that the then President, Rutherford Hayes received the first Siamese ever to be seen in the United States. This cat was a gift from the American Consul in Bangkok, and was called Siam, reflecting the country of her birth which is now better-known as Thailand.

Her journey to the White House took two months, with the cat finally being delivered to her destination in a Wells Fargo crate. Her stay here was literally short-lived however, as with many of the first cats brought to the West from the Orient during this period. They seemed to be very susceptible to respiratory infections, perhaps linked in part to the climatic change, and the lack of protective inoculations during that period in history. In spite of the very best efforts of the President's own physician, Siam passed away in October 1879. It is just possible that Siam may still be somewhere in a government building. Instructions were given on her demise that she should be preserved, but it is unclear as to whether this instruction was ever carried out.

Over recent years, a black cat called known as India 'Willie' Bush has been resident in the White House. She has been owned by the Bush family for over a decade, and her unusual name is derived from the nickname of Ruben Sierra, a famous baseball player from their home state of Texas, who was popularly known as "El Indio". Between 1989 and 1994, before becoming President, George W. Bush was a general manager of the Texas Rangers club for whom Sierra played. The family also owned another cat with a similar name, Ernie 'Willie' Bush.

Canadian Parliamentary Cats

The cats which patrol around the parliamentary buildings in Ottawa searching for vermin have been officially cared for since the 1970s. Irene Desormeaux, a great cat lover constructed a series of mock parliamentary buildings to

house what were effectively stray cats, in keeping with their surroundings. Rene Chartrand and a team of volunteers now care for the cats, all of whom are neutered and they roam freely in the vicinity of Parliament Hill. The refuge there is currently home to approximately fourteen cats.

Downing Street Cats

The tradition of cats being resident at the heart of British government is a tradition which dates back at least to the reign of Henry VIII (1509–1547). Only in during recent years, however, have they emerged out of the shadows into the public gaze. During the early years of the Second World War, a cat known as the Munich Mouser lived in Downing Street, first with Neville Chamberlain, whose ill-fated attempt to avoid war saw his departure from office, and then Winston Churchill. When Edward Heath came to power in 1970, there was a cat called Petra. She died in 1973 and a cat called Wilberforce succeeded her. He went on to serve under a total of four different Prime Ministers – which may well be a record in the history of Downing Street felines. Wilberforce is said to have so captivated the heart of 'Iron Lady' prime minister Margaret Thatcher that she returned from Moscow with a can of sardines specially purchased for him in a supermarket there.

Cats in residence at Downing Street have been treated as employees of the civil service. Their official role was to control the rodent population in what is actually a maze of old buildings dating back to the Eighteenth Century. Probably the most famous feline resident here was Humphrey, a black and white cat, who was charged with the responsibility of rodent control after the death of Wilberforce in 1987. He turned up as a stray and was named after the character, Sir Humphrey Appleby, who featured in a popular television series of the time, called

POLITICAL PUSSIES

Yes, Minister. This focused on the political scheming between ministers and civil servants in Whitehall.

In fact, scandal was never far away during Humphrey's time in office. He was wrongly linked to the death of a nest of young robins outside the window of Prime Minister John Major early in the summer of 2004, but lingering doubts over his involvement resurfaced later that year, when he was implicated in the death of a duck in nearby St. James' Park.

Humphrey's wanderings led to a premature notice of his death being published by the Prime Minister's press office in 2005. It later transpired that, possibly to avoid publicity, he had decamped to the nearby Royal Army Medical College, where he had been adopted as stray, under the pseudonym of PC, meaning 'patrol car'.

Things changed after the victory of New Labour in the 1997 general election. Talk of an alleged rift between Humphrey and the Blair family, who were the new tenants of Downing Street, gave rise to feverish press speculation. But the existence of any rift was always denied. In November that year however, it was suggested that Humphrey should relinquish the role that he had held for nearly a decade, and retire to the country. Much was made of his chronic kidney problems, which had first been diagnosed four years earlier. Under a cloak of secrecy, he moved to a new address in south London, with his departure only being confirmed after he had left Downing Street, because of fears that he might be cat-napped.

The absence of any photographs of Humphrey prompted stories to circulate; he might have been put to sleep or had simply died. Downing Street reacted by organising a trip for journalists to visit Humphrey in his new home. The resulting pictures appeared to confirm that he was in robust health, and had actually put on weight, having retired from his official role as Chief Mouser to the Cabinet Office.

Media interest in Humphrey was rekindled in 2005, when it was confirmed that he was still alive and well. Sadly, his death at the age of 18 years was announced the following March 2006 It also emerged that after Humphrey left Downing Street, he left behind his own personal file of official papers which was 1.5 in (3.75 cm) thick.

Postscript

After Humphrey's departure, no successor was appointed until Prime Minister Tony Blair retired from office in 2007. The most recent incumbent patrolling Downing Street is resident in the flat above Number 10, living with the Chancellor of the Exchequer Alastair Darling and his family. Sybil, named after the bossy character in the popular BBC television series *Fawlty Towers*, is another black and white individual. She moved in during September 2007, having been brought down from the Darling's residence in Edinburgh.

Loony Passports

One cat has risen to lead one of the United Kingdom's most colourful political parties. The Monster Raving Loony Party was set up in 1983 by a rock musician David Sutch, who was better-known to the public as Screaming Lord Sutch, and who campaigned hard at various elections on policies including the abolition of income tax. Following the party founder's death in 1999, the membership met to vote for a successor. The result was a tie between Howling Laud Hope, who was acting leader, and his cherished pet, Cat Mandu. The cat was hailed as being responsible for producing the party's mainfesto for the general election of 2001 – a blank sheet of paper. Sadly, this new era of co-operation in British politics came to a premature end in

July 2002, when Cat Mandu was killed by a car crossing the street.

However, Cat Mandu lived long enough to see a lasting policy change affecting cats, arising from a proposal put forward by the Monster Raving Loony Party in 1984. Its proposal for pet passports was laughed at by all the mainstream parties at that stage. But these were introduced by the British government in 2001 and now cats (and other pets) can travel through Europe and to a number of other countries and return to the United Kingdom without having to spend time in quarantine, subject to certain regulations.

SECTION FOUR

Heroic Cats

CHAPTER 1

Wartime Cats

TOWARDS the end of 1947, a stray cat gave birth to a litter of kittens at a dockyard on Stonecutters' Island in Hong Kong. When the British warship HMS *Amethyst* docked there for supplies a crew member spotted one of these kittens, looking desperately hungry. He took pity on the poor creature, and took it back aboard the ship, hoping that his captain would not object. On the contrary, the two struck up a close bond to the extent that the cat, who was named Simon (although he was also called Blackie on account of the colour of his fur), came whenever the captain whistled. He also became a valued member of the crew by catching rats which were a constant menace on-board the vessel.

In April 1949, *Amethyst* was ordered to head from Shanghai up the Yangtse River to Nanking, to protect the British Embassy there, in case of an attack by the insurgent Communist troops under the command of Mao Tse Tung. The ship came under fire even before it reached its destination, and ran aground on a sandbar. There were heavy casualties and the captain was among those who died. Simon was wounded by shrapnel which caused extensive blood loss and was badly burnt. Despite receiving treatment, it was thought unlikely that he would survive the night.

Meanwhile, *Ameythst* remained marooned while delicate negotiations for her release continued. Stores of food started to run short and with Simon laid up, the rat population multiplied. Incredibly, Simon regained his strength and

returned to his rat-catching duties. There was a particularly large and vicious rat which the crew had nicknamed Mao after the Communist leader, but it had proved impossible to trap. When Simon confronted this rat however, he dispatched it without difficulty, confirming his recovery was well underway. This was a big boost to morale, making Simon's presence more significant as conditions on the ship worsened.

With fuel and food running out, *Amethyst* was ultimately left with no option but to try to escape back down the river. The ship set off under cover of darkness on July 30, 1949, and although it sustained further damage, it managed to elude being sunk by the Communist gun batteries and finally reached the safety of the open sea. The ship docked back in England in November that year, and Simon was taken into quarantine for the compulsory six month period. His part in the *Amethyst* episode led to him being recommended for the Dickin Medal. This award was conceived by Maria Dickin, founder of the animal charity the PDSA, for animals displaying remarkable bravery in wartime service. Sadly, Simon's medal ceremony never took place. He died of acute gastro-enteritis, prompting an outpouring of national grief from the public who had followed his exploits for some time. Large numbers of messages of sympathy and flowers were received. It fell to Father Henry Ross to carry out the funeral service and Simon was buried in the PDSA's animal cemetery at Ilford in east London. The headstone marking his grave can still be seen there today. Simon remains the only cat amongst the sixty or so animal recipients of the Dickin Medal.

As a postscript, there is no likelihood of any other cat following in his footsteps, because the Royal Navy has banned not just cats, but all other live animals from its vessels since 1975. Yet the practice of having ships' cats was once so widespread during the Second World War that it was decreed all cats in naval establishments should wear

collars emblazoned with their names, so it could be determined as to which vessels they came from. The cost of this measure however, with a war to fight, meant that it was never enforced.

Lucky ... or not?

During the First World War, there were a number of postcards produced of ships' cats which sailors used to send home to their loved ones. Not all such cats were considered lucky however, as shown by the case of one on the German battleship *Bismarck* when it was sunk by British warships during 1941. He was saved by crew members of HMS *Cossack*, and became known as Unsinkable Sam. Unfortunately, this didn't prove to be the case, with this vessel being sunk too. Luckily, he was again rescued; this time by HMS *Ark Royal*, which itself was torpedoed soon afterwards. When Sam was picked up after this incident by the destroyer HMS *Legion*, and his history became known, it was decided to give him permanent shore leave, rather than allowing him to remain on the ship!

Cats in Aerial Combat

At least one cat saw active service with the Royal Air Force. This was Windy, the pet of Guy Gibson (1918–1944), who rose to the rank of Wing Commander and was awarded the Victoria Cross for bravery shown in the Dambuster raids over the Ruhr valley in Germany during World War II. It is unclear if Windy was with Gibson on the fateful last flight back from Europe, when his plane crashed near Steenbergen in the Netherlands after running out of fuel. His whereabouts were not recorded.

CHAPTER 2

Life-saving Cats

T HERE are a number of cases of cats who have helped
to save their owners from potential disaster. Mount
Vesuvius, a volcano on the Italian island of Naples,
has had a history of erupting violently, most notably in
AD 79 when it wiped out the cities of Pompeii and
Herculaneum. In 1944, an elderly couple living in the
nearby village of San Sebastian were trying to sleep in their
farmhouse when their black and white cat Toto started to
behave strangely. He came into their bedroom and woke
them up. After being placed back outside, Toto returned
again, and the farmer's wife decided that he must be
warning them about the volcano. They grabbed what they
could in a handcart and headed to a relative's home some
distance away. An hour later, Vesuvius erupted, destroying
the village and killing over 30 people. It is likely that Toto's
sensitive hearing probably detected the sound of the volcano
poised to erupt, in the same way that cats and other animals
seem able to determine other natural disasters, ranging
from earthquakes to tsunamis before they occur.

Late one bitterly cold winter's evening, American couple
Virgil and Linda Mcmillan came across a young stray cat
on the steps of their home in Berryville, Arkansas. The cat
was close to death through hypothermia and starvation
and they took him indoors into the warm. The couple
painstakingly nursed him back to health and called him the
'Slowly Cat' before changing the name to 'Old Slowly'. The
cat developed the habit of disappearing outside for a few
minutes every evening and then returning to sleep indoors.

One night, after he had been living with them for about two years, Old Slowly went out as usual but did not return. The temperature was well below freezing and the concerned couple went out to search for him, in case he was injured or trapped somewhere, but they could not find him. They resumed the search again in the morning, with a sense of growing anxiety. It was then that Virgil noticed an old sack lying on the ground, from which Old Slowly emerged, before going back inside again. Virgil went over to look at the sack and was horrified to discover a new-born baby inside. Old Slowly was curled up alongside the infant, licking his face. Doctors at the local hospital confirmed that if it had not been for Old Slowly staying with the baby overnight, the child would have died before morning. Luckily, for whatever reason, and perhaps even in some way because of his own experiences, the cat had saved his life.

CHAPTER 3

Crime-fighting Cats

ALTHOUGH the use of police dogs is now common-place for forces throughout the world, very few have resorted to using cats. Yet felines can make a contribution in one frontline battle – to protect the increasingly rare sturgeon fish which are hunted and killed for their highly-valuable roe (eggs) which is sold as caviar. Rusik was one such 'caviar cat'. He was based at a Russian police checkpoint at the port of Stavropol, close to the Caspian Sea and the centre of the illegal caviar trade. Presumably as a result of growing up in this area, Rusik displayed a remarkable ability to detect even small amounts of caviar hidden in vehicles. Tragically, he met an untimely end in July 2003 after being run over in suspicious circumstances by a vehicle in which he had previously located caviar.

Tracing a Killer

The study of the genetic material DNA and its discovery as a unique 'marker' has revolutionised the investigation of crime. It can be recovered from just a single hair – as killer Douglas Beamish found to his cost after murdering his common law wife Shirley Duguay on Canada's Prince Edward Island. But in this case, it was not one of Beamish's hairs that was used to prove his guilt, but that of the couple's white cat, Snowball. The police recovered some 27 cat hairs on the killer's jacket which he had buried with the victim's body. They then arranged for a blood sample to be

taken from Snowball to see if the hairs were from her. At that stage, however, when DNA science was a relatively new field, it was virtually impossible to find any laboratory able to undertake this comparison.

The police finally managed to obtain the assistance of the Laboratory of Genetic Diversity, part of the National Cancer Institute, which has its headquarters in Maryland. Technicians were called on to map the cat's genetic blueprint, known as a genome. It then proved possible to link the hairs directly back to Snowball, thus helping to secure Beamish's conviction for Shirley Duguay's murder. Realising the value of this work as so many homes have pet cats, the US Department of Justice then awarded a grant to the Maryland laboratory, enabling the scientists to pioneer a specific test to link hairs back to individual cats and aid in solving crime.

SECTION FIVE

Historical Cats

Cats on Voyages of Exploration and Other Well-travelled Cats

IT IS NOT only in wartime that cats have proved to be inveterate travellers. They were taken on the first voyages of exploration to the New World, and early in the Twentieth Century, cats were on-board ships sailing on voyages of Antarctic exploration. Robert Scott (1868–1912), who was later to die tragically in the region, first left London for the Antarctic aboard the vessel *Discovery* in 1901 with two cats, which are believed to have been named after areas of London.

One was Blackwell, a tabby and white who struck up a close bond with Scott and his Scottish Terrier, Scamp, as well as some of the sled dogs. The other feline was a black cat called Poplar who belonged to the ship's stoker, Arthur Quartley. Luckily, both cats were well-disposed towards each together.

Tragedy struck on the journey however, when Poplar was fatally attacked by the huskies, leaving Blackwell to complete the voyage alone. It was not without adventure, as the *Discovery* became trapped in the ice in 1902. It remained there for a second winter, before finally being freed by two other ships which had brought dynamite, enabling the crew of *Discovery* to blast a passage to safety. Both of these vessels also had cats on board, reflecting

a tradition that extended back to the earliest days of European exploration.

Ernest Shackleton (1874–1922) travelled to the Antarctic as the Third Officer on *Discovery*'s voyage, and then set out in command of his own expedition to the Antarctic aboard *Endurance* in 1914. A cat again featured as part of the crew, in the guise of a tabby tomcat, rather confusingly called Mrs. Chippy, who belonged to the ship's carpenter, Henry McNeish. The cat acquired his name from the crew because of his habit of following McNeish around on the ship rather like a nagging wife, with 'chippy' being a popular nickname for a carpenter.

Mrs. Chippy soon settled on the boat, and although initially alarmed by the prospect of sailing with some 70 Canadian huskies which were kenneled on deck, he soon became sufficiently confident to walk over the roofs – often pausing to scratch his claws and causing the dogs to start barking loudly.

The cat had a lucky escape on the journey south when he jumped out of a cabin window straight into the sea. The alert officer on watch heard what had happened, and aided by a very calm sea that night, the crew were able to retrieve Mrs Chippy after about 10 minutes. He was soaked but otherwise unaffected by the experience.

When the vessel reached the Antarctic and became trapped in the pack ice, Mrs Chippy disappeared for several days, causing the crew to worry in case he had wandered off and died as a result of the extreme cold. In fact, he had been in the relative warm below deck. He then spent much of his time there as he found it uncomfortable to walk on the ice. This didn't stop his fun with the dogs however. They had been moved off the ship and on to the ice and Mrs Chippy often wandered closed to them to carry on his taunting.

Against all the odds, expedition leader Ernest Shackleton managed to get his men home safely. Mrs Chippy did not return. After a last meal of sardines, and fond farewells

77

from the crew, he is believed to have been shot, probably by Shackleton himself. It was something for which Henry McNeish never forgave Shackleton and this lingering resentment poisoned the men's relationship from then on. Indeed, although it was entirely due to the carpenter's boat-building skills that the members of the expedition ultimately escaped with their lives, Shackleton never recommended McNeish for the award of a Polar medal.

The death of Mrs. Chippy haunted McNeish through to the end of his life in 1930. When the New Zealand Antarctic Society restored his grave in 2004 however, they also commissioned a life-size bronze sculpture of the cat from a local sculptor called Chris Elliott. He portrayed Mrs. Chippy in such a way that she is seen resting on the tombstone, just as she might have laid on McNeish's bunk aboard *Endurance*.

Shackleton sailed back to the Antarctic with another cat, on his final voyage in 1921. The cat in question was called Questie, being named after the vessel itself, which was called the *Quest*.

A number of other cats have sailed to the Antarctic; the first being a black and white cat called Nansen, who journeyed aboard a Belgian vessel known as the *Belgica*. He was named by the cabin boy after the Norwegian Antarctic explorer Fridtjof Nansen. Just like Mrs. Chippy however, Nansen's behaviour changed when the ship became trapped in pack ice. He slept for longer, and proved to be far less friendly, ultimately dying during the winter of 1897.

Cats continued to sail into Antarctic waters regularly, and the crew of a schooner called the *Penola* which carried out survey work in the region during the 1930s, were given a black and white cat called Lummo, by the Dean of Stanley Cathedral when they visited the Falkland Islands. He was clearly well-acclimatised to the waters of the southern Atlantic, even sleeping on a bed of snow in some cases.

Lummo stayed with the expedition throughout its time there, and then sailed back to England after three years at sea, living out his days on land with the family of one of the crew.

Boats, Planes and Trains

Cats have been carried on ships for centuries, mainly for the purpose of controlling vermin, although undoubtedly they would also provide the crew with some relief from the monotony of a long sea voyage. Explorer Christopher Columbus carried cats to the New World on his voyages of discovery back in the 1490s. The cat's hunting ability was vital in helping to prevent vessels being overrun with rodents which could otherwise threaten the food stores on-board, as well as the health of the crew.

One emerging breed, now known as the Maine Coon, became associated with ships plying back and forth to the Americas from Europe. It is closely linked with the state of Maine on the eastern seaboard of the United States. There are a number of stories about these cats which are told today, reflecting their nautical past, such as the way they curl up and sleep at strange angles, just as their ancestors might have done in cramped conditions on a ship.

Some accounts still survive of the bonds which were built up between sailors and their cats. Famous explorer Matthew Flinders sailed with his own cat called Trim. They first met on board HMS *Reliance* in 1797, when Trim was still a kitten. He was lost over the side of the ship, but managed to cling on to a rope and climb back on board, gripping on with his claws. Trim was then looked after by Flinders, with the pair proving inseparable thereafter. The kitten was named after the cheerful narrator Tristram Shandy – a fictional creation of the novelist Laurence Sterne (1713–1768), rather than from the nautical term of trimming the sail.

When Flinders was put in command of a ship called HMS *Investigator* and set sail in 1801 to travel around the entire coast of Australia, Trim was again at his side. Disaster nearly struck on the journey home however, when their replacement vessel, the *Porpoise* was wrecked on the Great Barrier Reef, off Australia's east coast. Undeterred however, Flinders managed to make Sydney, which lay some 700 miles (1126 km) away to the south, in a small boat accompanied by his faithful companion Trim, and ensured the crew were rescued.

The pair then set sail again for England in a schooner called the *Cumberland*. Flinders headed across the Pacific but made a fatal miscalculation when he decided to put into the harbour on the island of Mauritius. Unbeknown to him, war had broken out between Britain and France during the period they had been away and their vessel was captured by the French. Flinders was imprisoned but Trim came to find him, and was a regular visitor for a period. One day however, she simply disappeared, and Flinders suspected that she had been caught and eaten by some of the slaves on the island.

Distraught at his companion's disappearance, Flinders left a vivid description of Trim, referring to him as 'one of the finest animals I ever saw', with a body which 'was a clear jet black, with the exception of his four feet, which seemed to have been dipped in snow, and his under lip which rivaled them in whiteness. He also had a white star on his breast'.

The devoted nature of Trim is reflected in a sculpture on a window ledge in the Mitchell Library in Sydney, where Flinders' papers were donated by his grandson in 1925. There was a statue of Matthew Flinders himself for many years but then in 1996, it was decided to add a portrayal of Trim, watching over him from behind. It is dedicated to Trim's memory, using words written by Flinders himself. The plaque records him as being 'The best and most

illustrious of his race. The most affectionate of friends, faithful of servants, and best of creatures.' There is another stature of them together on the other side of the world in Flinders' birthplace at Donington in Lincolnshire.

On the waterfront

Cats and ships have become indelibly linked over the course of centuries, so it is perhaps appropriate that the Maritime Museum of the Atlantic, based in Halifax, Nova Scotia, has maintained a team of feline Rodent Control Officers. The first resident was a black female called Nannie, who had a litter of kittens on the retired hydrographic survey ship CSS *Acadia* soon after it was berthed at the museum in 1981. She then disappeared unexpectedly during an important football weekend three years later. It was suspected that she had been cat-napped and taken out of town.

A replacement was sought from the local animal shelter. She was called Lady Bilgewater – until it became evident that the presumed female cat was in fact male! Resembling the cartoon cat Sylvester (see page 190) in appearance, he was then called Bertram Q. Bilgewater, but better-known to his friends and associates as 'Bert'. He was something of a bruiser, willing to take on not just the local rat and mink populations, but also gulls and even large dogs. Sadly, he collapsed and died soon afterwards, and was greatly missed.

This led to a search for a successor, and again with the help of a local animal shelter, a longhaired tabby called Clara came aboard *Arcadia*. She has proved to be a wonderful mascot, if not the most energetic of cats, her main activity seeking sunny spots in which to sleep and the occasional stroll along the waterfront. Clara always looks her best, thanks to the attentions of a personal groomer.

Clara was joined in 2000 by Erik, a red mackerel tabby. He followed one of the museum staff called Steve Read back to the ship, and immediately adopted it as his home. His temperament is very different to Clara's though, and this has resulted in him using up a number of his nine lives. He wanders widely but generally finds his way home without problems, in spite of the concerns of well-meaning people who encounter him strolling along the waterfront. He now wears a tag on his collar saying that he knows where he lives!

In a freezing December 2007 however, there was widespread alarm when, Erik, whose curiosity overcame his judgement when inspecting some work on the waterfront, was seen to tumble down into the sea. Luckily, he was rescued in minutes, and with only his dignity damaged, he ran off as soon as brought back ashore. As the story of his escape from death broke, Erik was found safe and sound at the nearby offices of the *Daily News* newspaper, being comforted by the staff there, who know him well.

Long-distance sailors

There have been a number of cats who have spent almost their entire lives at sea. They include a Siamese cat who rejoiced under the name of Princess Truman Tao-Tai, and who sailed on a British iron-ore carrier after joining the crew in 1959. It was estimated that she travelled some 1.5 million miles (2.4 million km) during her lifetime up until 1975 – further than any other cat. Another long-distance traveller was Doodles, who was a popular figure on the White Star liner *Cedric*. She gained a reputation for wandering off into towns where the ship docked, and then instinctively returning before it sailed, never being left behind. Doodles sailed over a million miles (1.6 million km), and then retired in December 1933, living for the rest of her life at a hotel in the Peak District.

Feline nautical influences

The close relationship between ships and cats means there are a number of feline nautical terms. The cathead, for example is the beam carrying the anchor, with hanging the anchor here being described as 'catting' the anchor. The word 'catharpin' is used to refer to an iron cramp, or alternatively, a short length of rope. There is even a type of boat with a single mast described as a 'catboat', with its rigging being known as the 'catrig'.

Cat behaviour on board also provided a means for crews to predict the weather, even though this method is not reliable! Miaowing for example, was considered likely to be indicating an approaching gale, as was a cat running around wildly. Some meteorological changes are even actually described in feline terms. The way in which the wind blows may be referred to as 'how the cat jumps', while a light breeze, indicating a forth-coming squall, is described as a 'cat's paw'.

Planes

There have been a number of cases where cats have escaped on planes and disappeared, only to re-emerge months later, much thinner but suffering no lasting ill-effects from their experience. Hamlet, a black and white cat, ended up flying a record 600,000 miles (960,000 km) in just 52 days after escaping from his travelling container en route from Toronto to London. A search of the aircraft at Heathrow airport failed to locate him. A shocked engineer carrying out regular maintenance then found him when he removed a panel on the aircraft. Hamlet was very thin after his ordeal, having had nothing to eat for over seven weeks, but he had been able to remain alive by licking the condensation

within the area where he had become trapped. With his flying days behind him, Hamlet eventually settled down with his owner in Norfolk.

An even more remarkable journey involved a Siamese cat called Wan Ton, who was supposed to be living with an American service family on Guam, an island in the southwestern Pacific. Instead, he managed to evade security and board a flight to Washington DC in February 1979, and from here, he transferred unnoticed, to another flight and ended up at Heathrow. Luckily, this story had a happy ending. Thanks to the tag on his collar, it proved possible to locate his owners, and Wan Ton was flown back to them – a journey of some 11,200 miles (18,000 km).

While stowaway cats are not by any definition frequent travellers, at least one cat actually seemed to enjoy flying. Adolf, as he was affectionately known because of his seemingly mustachioed appearance, was another black and white cat. He approached an American pilot called Ed Stelzig based in Darwin, Australia, and a rapport developed between them. Adolf soon started to venture into the plane and slept on the warm radio equipment. He became a common sight around the airbase but remarkably, once he heard Stelzig start the plane's engine, he would always run to board the plane before it took off.

Only on one occasion did Adolf miss a flight when he jumped into another plane by mistake. But Adolf was well cared for by the crew during Stelzig's week long absence and returned to flying immediately after the pilot's return to Darwin. When Stelzig's tour of duty ended, Adolf had clocked up 92,140 miles (147,424 km) of flying. He remained in Australia and found a good home close to the airport.

Trains

Cats are often seen around rail stations, with a few having actually developed a taste for train travel. Toby, based at

Carlisle station, was given his own 'travel card' – a collar tag which asked that if he was found on a train, he should be sent back to his home station, where he lived in the refreshment room. He generally avoided passenger trains, preferring fish trains. On one occasion, he journeyed right up to the Scottish port of Aberdeen – a distance of some 245 miles (392 km) – although sometimes he preferred to take the milk train instead. Unfortunately, he failed to appreciate the safety notice about crossing the track, and was fatally injured by a train coming the other way on February 12, 1933.

One cat who lived at London's Paddington Station in the 1970s became a well-known figure, especially to female passengers passing through this busy mainline station. Tiddles had been adopted as a kitten by June Watson, the attendant at the ladies' toilets – and that was where he spent his time. Those passing through the station each day used to drop off special treats such as steak. Tiddles was no travelling cat, preferring a life of little activity, and that meant his waistline expanded dramatically.

Meanwhile, the food just kept on coming; to such an extent that it was necessary to buy a fridge to keep it in. Tiddles became seriously obese. He continued to pile on the pounds unchecked until his death in 1983, when, barely able to walk, he tipped the scales at a staggering 32 lb (14.5 kg). This is about three times heavier than the weight of an average cat. But Tiddles is not the heaviest cat on record. This dubious distinction belongs to a cat called Katy from Russia. She tipped the scales at 44 lb (20 kg), her massive weight maintained by her appetite for sausages, which she could eat at the rate of 1.5 per minute.

Many cats meet a premature end when they encounter cars, but Button's experience ended happily. Like most cats, she liked to sleep in warm places but at eight years old, she should have known better than to curl up under the bonnet of the neighbour's car. Fraser Robertson then set

off for the long drive from Norfolk to Aberdeen. When he pulled into a service station to check his oil, some six hours and over 300 miles (490 km) into his journey, he was shocked to discover Button covered in grime and in a distressed state hiding behind the battery.

Fraser managed to entice her out and gave her some food, after which, she settled down on the backseat, and went to sleep, deciding this was a much more sedate way of travelling. Once they reached Aberdeen, and the story spread, an airline offered to fly Button back to Norwich airport, from where her owner took her the short distance back home.

Space travel

Cats have even travelled into space. The first to blast off from earth was a black and white tom called Felix who, before he found international fame, lived on the streets of Paris. In 1963, after a period of training, he was strapped into the spacecraft at a French base in Algeria, North Africa, and sent 130 miles (240 km) above the planet. The capsule containing Felix then separated from the rocket, and, with its parachute deployed, came down to earth, leaving Felix unharmed by the experience.

Feline Independence Reasserted

Cats are creatures who generally appreciate a set routine in their lives, as shown by Old Slowly (see page 71). They can establish a very clear understanding of their surroundings, with tom cats in particular wandering over a relatively wide area. They also have strong homing instincts. This has now become a significant area of scientific research, with the first investigations into this field carried out by an American professor, Francis Herrick in 1921. He drove his cat five miles (eight km) from his home in

Columbus, Ohio, and tracked her as she found her way home. Professor Herrick discovered that the cat travelled roughly in a straight line, clambering under hedges to do so, and unerringly seemed to know the way home, almost without hesitation.

There have been many more puzzling cases of cats travelling long distances to be reunited with their owners, as typified by McCavity. In 1960, he walked virtually from one end of Britain to the other, from Truro in Cornwall, right up to Cumbernauld near Glasgow – his previous home. He covered this distance of some 500 miles (800 km) in just three weeks, but he then died soon afterwards, probably from the effects of the journey.

More than 200 documented cases of cats covering long distances have been recorded. It seems that on average, they travel about three miles (five km) per day, pausing to hunt on the way. Cats rely partly on the earth's magnetic field to orientate themselves, and then, in familiar territory, they can use features in the landscape to find their way to a particular spot. There is still the mystery, however, of how cats can track down people in places they have never been before.

Scientific Cats

C ATS HAVE played diverse roles in the advancement of science, as the following examples reveal.

The Sparking Cat

Electricity exists in nature, but harnessing this force to benefit people was one of the great challenges of the late Nineteenth Century. Part of the early inspiration which ultimately led to a solution, stemmed from a cat called Macek. He was the family pet of Nikola Tesla and his parents who lived in Serbia. When Nikola was just three years old, there was a remarkable build-up of static electricity in the atmosphere. As people walked along the street in the snow, their footprints glowed, but it was the effect on Macek that was to shape Nikola's future. When he stroked his pet, a shower of crackling sparks caused by the static electricity buzzed off the cat's back. In the darkness of the evening, Macek actually glowed with light. This provided Nikola with a lifelong interest in science, and he made a major contribution to adapting the power of electricity for domestic use, after moving to the United States.

The Feline Researcher

There was a cat who played an even more direct role in scientific studies involving energy, aiding his owner Professor

J.H. Hetherington, from Michegan State University in his research. The professor asked a colleague to review a copy of his paper. This was long before word-processing meant that changes to documents could be made easily. The reviewer highlighted the professor's use of 'we' and 'our' stating that the plural was wrong when there was only one author. This meant that before it could be submitted to the relevant journal, the whole document would have to have been laboriously retyped again. In desperation and with the deadline looming, the professor decided to find a junior author, so only the first page would have to be retyped. That fellow author was his Siamese cat, who was duly acknowledged as F.D.C. Willard – the initials F.D. for the cat's scientific name *Felis domesticus* and 'C' for his pet name 'Chester'. His sire was a tom called Willard.

Professor Hetherington then attributed a subsequent controversial paper to his feline companion alone, and the ruse would have gone undetected, had it not been for an unexpected visitor to the university. The professor was out and the visitor asked to meet F.D.C. Willard instead. Even today, authors of scientific papers still quote F.D.C. Willard's publications in their bibliographies.

Newton's Cat

The great physicist Sir Isaac Newton (1642–1727), is best-known for his theory on gravity, but made significant contributions in other areas too. He came up with a practical solution when his work was constantly inter-rupted by his pet cat, which would miaow loudly to be let in or out of his house. This led Newton to pioneer a door which the cat could open by himself, enabling him to come and go as he wished. Along with his other more notable achievements therefore, Sir Isaac Newton was also the creator of the world's first cat flap.

Schrodinger's Cat

In the field of physics, one of the most difficult areas to understand is quantum mechanics. This is because the subatomic particles which are involved simply do not move in a way that can be predicted, unlike the orbit of a planet such as the Earth around the sun. German physicist Erwin Schrodinger decided to try to explain the relationship between electrons orbiting around an atomic nucleus by using the example of a theoretical cat. This cat was confined to a box along with a radioactive atomic nucleus, and a canister of poisonous gas. There was exactly a one in two chance that the nucleus would decay within an hour, releasing the poison and killing the cat. But according to the behaviour of subatomic particles, an onlooker could influence the outcome simply by looking at the cat. It would therefore be possible to decide whether or not it lived or died.

Inside the box however, the nucleus could be both decaying and yet not decaying, so the cat could theoretically exist in two states, and so may or may not be dead. As a result, if the box is opened, this process continues, creating what are effectively parallel universes. In one of these, the cat is alive, while in the other, it is dead. Interest in Schrodinger's cat has broadened out today from the world of quantum mechanics to represent a popular concept of the time-space continuum, in the field of science fiction.

College, Museum and Library Cats

W HO SAYS cats are lazy? At least one has found it easy to get into college. In 2004, an investigation in Pennsylvania focused on the sale of college degrees online from an institution calling itself the Trinity Southern University, supposedly with headquarters in Plano, Texas. As part of an undercover sting operation, a would-be student called Colby Nolan applied to the university. He had apparently already undertaken three college courses, as well as working in a fast food restaurant and also delivered newspapers.

There was no studying involved. As soon as his payment cleared, Colby was sent his diploma. Like most proud graduates, he had his photograph taken in academic dress, and this was published in a newspaper. Colby's achievements were truly remarkable however, given that he was a six year-old cat, who belonged to one of the staff working in the Attorney General's offices. And he certainly couldn't read or write. The bogus university was shut down as a result of its former alumni's discovery.

Museum cats

It is not just in distilleries (see page 103), where the rodent-hunting skills of cats can be helpful. There has been a tradition of keeping cats at the Hermitage in St. Petersburg, Russia which dates back to the 1742–1761 reign of Empress

Elizaveta Petrovna. Then, the Hermitage was the summer palace for Russia's rulers, and in danger of being over-run by rodents. Elizaveta signed a decree for cats from the city of Kazan to be collected to combat this threat. She was particularly keen to acquire large cats, believing they would be the most effective mousers.

They soon became known as the Winter Palace cats, and continued to thrive under the rule of her successor, Catherine the Great. The cats even remained after the Russian Revolution, when the area was overrun by Bolsheviks. The population finally succumbed in the Second World War, when the city, by then called Leningrad, was under siege by the Germans. However, new recruits were immediately sought after the war. Today, there is a population of around 50 cats there, with an annual sale of art organised by children of the museum staff raising funds towards their upkeep, neutering and general health care. The cats sleep in the heated basement of the building in winter to avoid the worst of the bitter weather, but in summer, spend most of their time wandering outdoors. The cats are no longer allowed into the building alongside the exhibits but they still remain a popular sight with visitors.

Author Ernest Hemingway (1898–1961) was a keen cat lover. He amassed a collection of some 30 cats at his Cuban home overlooking Havana. They caused such chaos that his wife Mary insisted he built them their own quarters, away from the main house. This was only partially success-ful however, as before long, Hemingway's favourite cats including Friendless Brother and Crazy Christian, were back in the house. Hemingway even decided to see if he could create his own breed, crossing beautiful Angoras with the local Cuban cats.

It was very much the same at Hemingway's other house in Key West, Florida, which now forms part of a museum. It also remains home to some sixty cats, some of which are direct descendants of those kept by the author.

A ship's captain gave Hemingway a cat with extra toes which he christened Snowball. Cats typically have five toes on each front foot and four on each hind foot. The strange characteristic – described as polydactylism – of Hemingway's cats, became quite widespread. Today, some of the resident cats at the Ernest Hemingway Home and Museum have up to seven toes on each front foot but do not appear to be seriously handicapped because of it. Additional toes on the hind feet are less common. These cats could almost be described as a breed, although to most cat enthusiasts, their defining characteristic is a freak of nature. None of this matters to the cats of course, many of whom are named after film stars such as Audrey Hepburn and Spencer Tracey. Surplus kittens were once sold to visitors, but now breeding is strictly controlled, with the aim of simply maintaining the population and most of the cats are neutered. But there is a 'cat cam', with images of the cats in the grounds of Hemingway's former home broadcast worldwide over the internet.

Library cats

There is something calming about cats in libraries, and their presence in such institutions is part of a very long tradition. This extends right back to the dawn of the domestication of the cat in Egypt, where they would often be found in libraries keeping rodents under control. At the present time, there over 270 library cats worldwide, the majority of which are to be found in America. A Library Cat Society was founded in 1987 by Phyllis Lahti of Minnesota. She had rescued an injured stray which turned up outside her home in a severe blizzard, but when she tried to introduce him alongside her existing two cats, they made it very clear that they were not interested in being joined by another feline companion. Phyllis therefore decided to take him to work with her at the Bryant Public

Library, where 'Royal Reggie' as he became known, readily settled in the Reference Room.

In 1998, a cat turned up on a bitterly cold January night at the library in the small mid-western town of Spencer, Iowa. Staff found him one morning deposited down the book return chute. In spite of the trauma he had suffered, the long-haired red tabby was very friendly, and made no attempt to scratch or bite as they helped him to warm up again. The idea of adopting him as the library resident received overwhelming support, with a local vet providing the cat with 'a city employee discount'. He was christened Dewey Readmore Books, but was frequently just called 'Dewey', after the classification system used for books in libraries. He became something of a town mascot, thanks to his friendly nature.

During his later years, Dewey suffered from various medical problems commonly associated with old cats, such as hypothyroidism and arthritis. His life came to an end in November 2006, when he would have been at least 18 years old. In April 2007, Dewey's life story was sold to a publisher in a fiercely contested auction and for an advance said to be in the region of $1.25 million (£62m). A film based on his life story, starring Meryl Streep, and entitled *Library Cat* was released in 2009. It is therefore clear that Dewey's involvement with libraries will continue long after his death.

What's in a name?

In any survey listing popular names for library cats, then undoubtedly, Dewey would feature high on the list. The trend may have started with Dewey Decimal. He was a tabby and white cat who lived at Cazenovia Public Library, in Madison County in the Syracuse area of New York State from 1985 to 1988. Seymour Library in Auburn, Cayuga County, in the same state, is currently home to a Dewey

who is black with a white bib, and known affectionately as Little Dewey. Further south, at the Umatilla Public library in Lake County, Florida, another Dewey Decimal is to be found. She looks rather like a cross-bred Himalayan, or colourpoint longhair, as the breed is also known. This cat prefers more of a behind-the-scenes role rather than meeting the public and often relaxes alongside the librarians in their office, sometimes playing with her younger red tabby companion, Page Turner who joined the library in September 2007.

British Library Cats

The Hypatia Trust in Penzance, Cornwall, has a tradition of cats in its libraries, thanks largely to founder Melissa Hardie, a keen cat-lover herself. Cats can also be found in various university libraries. Sam was a much-loved resident at the Rosemary Murray library of New Hall College in Cambridge, being fondly remembered by generations of students studying there between 1990 and 2003. A black and white cat called Simpkins moved into the library of Hertford College, Oxford in 2000. But the distinction of being the oldest cat in a British library probably falls currently to Tiggy, a tortoiseshell who has been at Holbeach Library in Spalding, Lincolnshire, for nearly twenty years.

CHAPTER 4

Cats in Churches and Mosques

THE RELATIONSHIP between cats and the church has been fraught with difficulty in the past because of the perceived links between Satan and cats, which developed in the Middle Ages. In more recent, enlightened times however, there have been a number of cases where cats have sought sanctuary in the confines of a church. Tom was one such individual. He was discovered as a kitten playing in the churchyard of St. Mary Redcliffe Church in Bristol in 1912. No-one knew where he came from, but he was subsequently cared for by the verger Eli Richards. Tom seemed to like organ music and sat next to the organist both when he was rehearsing and also during services – although he occasionally preferred to sit on the lap of someone in the congregation at this stage.

Active by nature, Tom repaid the kindness shown to him by the church by hunting rodents and the pigeons which created a considerable amount of mess with their droppings. A creature of habit, Tom would generally hide their remains close to the altar cross. The scale of his efficiency in controlling these birds was revealed by the bones and feathers found during repair work and which filled a bathtub three times. Tom died at the grand age of 15 in 1927. He was given a funeral in recognition of his service and devotion, and was buried just outside the main door of the church. A small memorial plaque commemorating 'The

Church Cat 1912–1927' marks his grave – the only one in the grounds of this church.

There are other graves of cats within ecclesiastical boundaries, including the grand surroundings of Salisbury Cathedral, whose spire is the tallest in the country. In 1980 however, Captain, the resident black and white cat, became involved in an altercation with a German Shepherd Dog. Although apparently unharmed physically, he disappeared and no successor was chosen. But a number of other cats remained living in the vicinity of the cathedral. These included Ginge, who died in 1988, and his sister Tiddler, who passed away two years later. They were buried next to each other under one of the mulberry trees growing in the cathedral grounds, their graves marked with small engraved tablets bearing their names.

The tradition of the cathedral cat has recently been revived with the arrival of black cat Wolfie, who belongs to the Dean, Canon June Osborne. He wanders widely and climbs up ladders and scaffolding while repairs are being carried out on the cathedral.

The role of the ecclesiastical cat was defined by Christopher Smart, an Eighteenth Century poet, writing about his cat Jeoffry who provided the inspiration for the poem *Jubilate Agno*. Today, the Church of the Advent in Boston, Massachusetts, even carries advice on cat care, under the guise of a 'public service message' from the church cats, highlighting lesser-known aspects of concern, such as the toxicity of lilies and other plants. The current feline members of this church are Jeoffry, with his black fur, being named after Smart's cat, and a black and white individual called Jake. They sometimes participate in Sunday Mass and sleep in the aisle, as well as becoming involved in other church activities.

Prior to their arrival, a black cat called Bradley held the church cat post up until his death in 2004. Father Grey who is responsible for the church, also has another two cats

living with him at the rectory. Skippergee is tortoiseshell and white (better-known in the United States as a calico) while Owl is a interesting individual. He has the pointed appearance characteristic of Siamese-type cats, but also has extra toes and is a descendent of a Scottish Fold, as reflected by his flattened ears.

The Muslim faith

While the Christian religion has been hostile to cats in the past, the links between the Muslim faith and cats are traditionally much stronger. This is because of Muezza, a cat which lived with the Prophet Mohammed. On occasions, the Prophet would actually allow Muezza to continue sleeping in his lap, while he gave sermons (see page 169). Once, when called to prayer and Muezza was lying on the sleeve of his robe, Mohammed cut off this part of the garment so as to leave his faithful pet undisturbed. The cat greeted him on his return by bowing, and he stroked her three times. She was hence guaranteed a place in the after-life. Her name is even represented by that of the Muezzin – the public crier who summons the faithful to prayer. Cats are allowed to wander freely in and out of mosques. The Prophet also used water drunk by his pet for *wudu* – the ritual washing of part of the body in preparation for prayer.

There is another story which may help to explain the Prophet's devotion to cats, that of a feline saving his life. This occurred when a venomous snake managed to conceal itself in the sleeve of the Prophet's garment. A cat was summoned to persuade the snake to leave, but when the reptile showed its head, the cat then grabbed it and pulled it out, keeping the Prophet safe. Even today, harming a cat is regarded as a serious sin in Islamic culture, and cats cannot be sold for money or traded for goods. In contrast, the cat is the only domestic animal not referred to in the Bible.

Faith

One of the most remarkable stories involving a church cat came at a time when the German bombing campaign was at its height over London during the Second World War. A stray cat called Faith went to St Augustine's & St. Faith's Church, on Watling Street, near to St. Paul's Cathedral, in 1936. She had crept into the church three times before but had been ejected by the verger. One night, however, she went unnoticed and was not spotted by the Rector until the next day. Father Henry Ross decided she could stay until someone claimed her. But no-one came forward and she became the church cat. Father Ross named her Faith, because of the way in which she had persevered coming back into the building in search of sanctuary, in spite of having been repeatedly put back on to the street.

Faith soon settled in her new surroundings and became a favourite with the parishioners. In August 1940, several commented that she appeared to have gained weight quite markedly. The reason was soon apparent when, later that month, Faith gave birth to a black and white kitten, who was christened Panda. All seemed fine, but on the evening of September 6, Faith started behaving strangely, refusing to settle down as normal. She persisted in wanting to be allowed to go down to the basement of the church.

After a brief inspection, she returned, and then carried Panda back down the steps with her, before reappearing for a meal. Father Ross decided to investigate and brought Panda back up again, placing him back in the basket, much to Faith's evident distress. He then went into the church to conduct a service, but unusually, was not accompanied by Faith. She and her kitten had again disappeared back down to the basement by the time he returned. Once again, Father Ross carried them upstairs, before Faith vanished there again with her kitten. Finally, the priest decided to leave the cats where Faith clearly

wanted to be, and moved some items out of the way to create a larger area for them.

The following day, there were heavy bombing raids over central London and many people were killed. The same happened on September 9, with the air raid beginning when Father Ross was heading back from a meeting in Westminster. He was forced to spend the night in an air-raid shelter. As he arrived at Watling Street the next morning, it was immediately apparent that his church had taken a direct hit and had been largely destroyed. Four floors had collapsed and only the tower was left standing.

Although there seemed little chance that Faith and Panda had survived, Henry was determined to search for them, in spite of the danger that what remained of the roof could collapse. He thought he detected a faint 'miaow' when calling Faith's name. Moving debris aside, he found her safe with her kitten and rushed to move them to a safer location, locking them in the tower vestry. Soon afterwards, the roof timbers gave way, crashing down on the area where the cats had sought sanctuary.

The church re-opened in a modest way for services again on November 1st. As the war drew to a close, the parishioners nominated Faith to receive a Dickin Medal for her bravery. These were awarded by the animal charity the People's Dispensary for Sick Animals (PDSA) for bravery, but only to pets linked to the armed forces or serving in a civil defence role. However, Mrs. Dickin decided to make a special award of a medal to Faith when she heard of this case. Father Ross was amazed on the day of the award when the Archbishop of Canterbury arrived to take part in the presentation ceremony. Faith sat at the rector's feet as usual and behaved impeccably. After the award was made, she received a meal of fish.

Faith's story was also reported in the United States and she received a second bravery award from the Greenwich Village Humane Society of New York. She carried on living

with Father Ross, while Panda found a new home at a residential care centre. Three years later, on September 28, 1948, Faith died peacefully in her sleep. Her funeral was reported worldwide, and she was buried close to the gate to the churchyard. Henry declined all offers of another cat, but would spend time reading close to her grave. But this was not to be the end of his involvement as far as the Dickin Medal was concerned (see page 69).

Heartfelt Grief

The novelist Thomas Hardy (1840–1928) was so overcome by the death of his cat that he determined, having written a long poem to his pet's memory, he would never own another cat. Finally though, in old age, he relented when he was given a blue Persian, called Cobby. The two became inseparable, but after Hardy's death, Cobby disappeared and was never seen again.

In the period immediately following the great man's passing, a missing cat attracted little attention. There was a national outpouring of grief, with Hardy's ashes being placed in Poet's Corner in Westminster Abbey. But his loyalty to Dorset was such that it was unthinkable his passing would not be commemorated in some way in the village of Stinsford where he had lived. It was decided to bury Hardy's heart in the grounds of St. Michael's Church in the village. (The plot is still marked accordingly today).

A doctor removed the organ from the body. It was then wrapped in a tea towel and left in a biscuit tin, awaiting its transfer to the specially-prepared urn, in which it was to be buried. Cobby the cat was in close attendance. Hungry and left on his own, he pushed off

the lid and quite literally, is thought to have stolen Hardy's heart. When the undertaker returned and saw what had happened, he decided it remained his solemn duty to bury the heart. It is believed that he took it upon himself to kill Cobby, burying the cat with the remains of the heart. This was never revealed to the congregation however, although some of the mourners were puzzled as to why a large polished wooden box had replaced the small bronze urn, which had been designed to match the one in which his ashes were interred in London.

Champion Cats

I T IS NO coincidence that the best mouser cats tend to be those who are reared on farms, rather than their pure-bred cattery-reared cousins. This is because although all cats have an instinctive desire to hunt, only those which learn to refine this skill alongside their mother are likely to be talented in this respect. Even then, there can be marked variations between individuals.

Champion Mouser

The champion mouser of all time was Towser, who worked at the Glenturret Distillery in Scotland, controlling the rodent population attracted by the barley being stored there. This long-haired tortoiseshell cat lived in the still house on the site for nearly 24 years, from April 1962 until her death in March 1987. It is reckoned she single-handedly dispatched some 28,899 mice during this period. Her success was emphasised by the fact that her successor, Amber who was resident at the distillery for approximately 17 years, was never seen to catch a single mouse!

The post of distillery cat today is shared between a black and white queen called Brooke and a red tom called Dylan, both former strays. In spite of proving excellent ambassadors for the many visitors to the distillery every year however, neither has displayed Towser's talents. No-one knows what made Towser so dedicated to her task although some suggest that by having a little of its product added to her nightly saucer of milk, she came to understand

the value of protecting the distillery from being overrun by rodents! A bronze statute of Towser with an inscription revealing her remarkable achievement is located at the entrance to the visitor centre.

Cats have been kept as a means of vermin control at distilleries for at least 200 years, but modern health and safety regulations seem to be bringing this role to an end. The passing of Barley, who died as the result of being involved in a car accident in March 2006, marked the last in the line of cats who patrolled at the Highland Park distillery on the remote Orkney Islands for nearly 200 years. Barley didn't just terrorise the rodent population during his fifteen years at the distillery, but he also intimated the manager's dog to such an extent that on one occasion, the poor animal became paralysed by fear and had to be carried away from his tormentor. As far as visitors to the distillery were concerned though, Barley was always the model host, and he received many presents and cards, particularly at Christmas.

Matters of Life and Death

While cats have been highly-valued as a means of controlling vermin, dating right back to the earliest days of their domestication, so unfortunately, have they also had harmful effects on wildlife in some parts of the world. A tabby cat called Tibbles is especially notorious amongst ornithologists, because he was responsible for single-handedly wiping out an entire species. This happened on Stephens Island, a tiny rock of an island measuring approximately a square mile (2.5 square km) off the northern coast of New Zealand.

The island was home to a small flightless wren which had survived successfully for countless thousands of years until Tibbles' arrival. He was brought here by the lighthouse keeper David Lyall as a companion, and amused himself by killing the wrens which scampered around like

mice. Tibbles killed over a dozen. Lyall kept some of the corpses which eventually came into the hands of Lord Rothschild, a great collector of rare and unusual specimens in his private museum back in Hertfordshire. It soon became clear that not only was the Stephens Island Wren quite unique, but also that it occurred nowhere else, other than on that small island. Thanks to Tibbles, however, this is the only modern-day species that has become known to science from fresh specimens after it became extinct.

Chapter 6

Cat Breeds and Their Origins

THERE have been a number of highly influential individuals within the world of the pure-bred cat which have played a vital part in the evolution of a particular breed. There was Kallibunker for example, the founder of the Cornish Rex breed which is distinguishable by its curly coat. He was born amongst a litter of cats with normal coats in 1950, at a farmhouse on Bodmin Moor in Cornwall. It soon became clear that he was very different from his littermates, thanks to his wavy coat. His breeder took advice on how best to develop the mutation. Surprisingly however, there was little initial interest amongst other cat owners at this early stage, although the breed has since become popular worldwide. All today's Cornish Rexes trace their ancestries back to Kallibunker.

A similar situation arose a decade later in the neighbouring county of Devon. There was a large stray with an unusual coat which lived in a disused tin mine. He mated with another stray in the area, who gave birth in a field adjoining the garden of a Miss Beryl Cox. She remembered the case of Kallibunker, and took in the strange-coated kitten which had been born, calling him 'Kirlee' (see page 158). He was used to establish what is now known as the Devon Rex breed, being quite distinct in genetic terms from the Cornish Rex bloodline. Kirlee lived for a decade and helped to ensure the breed was already well-established

when he died ten years later, following a collision with a motor vehicle.

In 1987, yet another rex mutation arose from an individual cat, who in this particular case became known as Miss De Presto. She was part of a litter of ordinary kittens handed into an animal rescue shelter in the American state of Wyoming, but stood out because of her curly coat. In terms of coloration, she was a dilute tortoiseshell, also sometimes called a blue-cream. Cats descended from Miss de Presto are now known as Selkirk Rexes because of the Selkirk Mountains in their home state. They too, have built up an international following. They are large, powerfully-built cats with long coats, although it takes about ten months for this feature to develop fully.

The most striking changes in the appearance of domestic cats have therefore tended to be as the result of spontaneous genetic changes which crop up unexpectedly in a litter, rather than being created by breeders. But the route to ensuring the development of a bloodline can be fraught, as was the case with the Scottish Fold. In 1961, a white cat called Susie attracted the attention of a shepherd called William Ross, who lived near the village of Coupar Angus. Her ears were folded down at the tips. The owner promised him a kitten of this type if another was born in the future.

Two years elapsed until Susie produced two kittens with similar ears to herself. One was neutered, while the other was kept by the shepherd and his wife, and called Snooks. Then disaster struck when Susie was killed by a car. This meant that again the future of this new potential breed depended entirely on Snooks. Fortunately, she produced some offspring displaying this characteristic, of which the most famous was Snowdrift. He was widely used as a stud cat in the early days, siring some seventy-six kittens over the course of three years, over forty of which had folded ears.

A different but no less radical change in the appearance of the cat's ears can be seen in the case of the American

Curl. These cats, occurring like the Scottish Fold in both short and longhaired variants, are all descended from a stray kitten which decided to adopt John and Grace Ruga, a couple living in Lakewood, California. She was a black, longhaired cat with a silky coat and curved ears. They called her 'Shulamith', and when she gave birth to a litter of kittens later in 1981, two of the four also had similarly-shaped ears.

While controversy has surrounded both the Scottish Fold and the American Curl because of their unusual ear shape, the Munchkin has proved to be by far the most talked-about of modern cat breeds. It is named after the little people from *The Wizard of Oz*. What sets the Munchkin apart from other cats is its very short legs. This characteristic was seen in the breed's founder, a black-coated stray called Blackberry who was found in Rayville, Louisiana. Sandra Hochenedel rescued her and her companion, a similar, short-legged blue cat when they were hiding under a truck to escape from a bulldog.

Blackberry was pregnant and soon gave birth to a litter which included another short-legged cat. He was called Toulouse and so began a breeding programme to build up the numbers of these cats. Munchkins have since proved to be remarkably robust in spite of initial fears as to whether they would be afflicted by intervertebral disc problems, like Dachshunds. As for Blackberry, she played no on-going part in the bloodline which she founded. One day, she simply disappeared from Sandra Hochenedel's home and was never seen again.

These are the success stories where a particular cat has played a vital role in establishing a bloodline. Equally, there are cases in the history of the cat fancy where breeds of this type died out at an early stage rather than being developed. In fact, there are several earlier reports of short-legged cats resembling the modern Munchkin from England during the 1930s. Although these cats bred over

several generations, they died out during the Second World War. A number of different 'rex mutations' have also been recorded but they have vanished, although there is the possibility, with the genes still circulating in the cat population, that one with these characteristics may crop up again unexpectedly in the future. It is not just a coincidence that all the cats which have created new breeds were non-pedigrees rather than existing pure-breds as their blood-lines are generally very restricted.

Back in ancient times, cats were a common site around the temples in the far east, much as they are still today in some localities here. A remarkable story has grown up about one of the early representatives of the Birman breed, which has very distinct markings. According to legend, there was a cat called Sinh, living at a temple at Lao-Tsun, on Mount Lugh in Burma. The temple housed a statue of Tsun-Kyan-Kse, a golden goddess with blue eyes. The cats were regarded as sacred because of the belief that when the monks died, their spirits passed in the bodies of the temple cats and would then reach heaven when the cats died.

Legend tells how one day the temple was attacked when the high priest Mun-Ha was sitting with Sinh close to the statue. The elderly priest collapsed, and as he lay dying of a heart attack, Sinh touched his body. The cat's appearance was immediately transformed and his extremities darkened to resemble those of the earth – except where his paws had been in contact with Mun-Ha which remained pure white. His body changed in colour too, becoming golden like that of the statue, and his eyes turned blue. Seeing this miracle occur, the other monks fought off the would-be looters, but Sinh died soon afterwards, conveying Mun-Ha's soul to heaven. Before long however, other cats resembling Sinh started to appear at the temple. They then indicated that a young priest called Lioa should become Mun-Ha's successor, by gathering around him.

The way in which the Birman reached Europe is also an unusual story. It is said that there was an uprising near the temple in 1916 and two Europeans helped the priests and their cats to escape. In recognition of the men's bravery, they were then sent a pair of Birmans. Only the queen managed to survive the arduous overland journey from Burma to France. She was pregnant, and gave birth to a single kitten soon after her arrival. This provided the basis for the development of the Birman breed in Europe.

As the years passed, breeders became increasingly sceptical about this exotic story. It was suggested that it may have been dreamed up simply to publicise the breed in the early days of its development, and that such cats were actually a European creation, bred from crossings between Siamese and long-haired cats. But then in 1960, an American cat enthusiast called Gertrude Griswold was given a pair of cats by a friend, Carter Townes who had brought them back from Cambodia. They displayed the unmistakable characteristics of the Birman breed. He told her how they were known as Tibetan temple cats and were considered to be sacred by the monks. Because of this, they could only be acquired as gifts.

CHAPTER 7

Feline Visitors

IN SOME cases stray cats may simply arrive and set up home in surroundings where they feel comfortable, remaining there for the rest of their lives. Their origins may be a complete mystery, and yet they can prove increasingly friendly towards those who care for them. This happened with Katy, a distinctly-marked tortoiseshell and white cat who adopted the Trolley Museum in Fort Smith, Arkansas as her home in 1997. She became very popular with staff and visitors alike, possibly becoming too popular for her own good. Frisco, a tabby tom cat, came along in 2002, living happily alongside Katy, who then disappeared later that year. There were suspicions that she might have been cat-napped, as all that was found was her collar with her name tag and address.

The daughter of the museum's founder then brought in another stray to keep Frisco company. She was called Casey and was more than happy to share life with Frisco. Both cats, however, are rather dismissive of human attention. Then in December 2003, a blue cat turned up and immediately adopted the cab of a steam locomotive as a vantage point from which to survey the museum. Smokey, as she was named, had a litter of four kittens and became far more friendly at this stage. The kittens were found good homes, and Smokey was neutered. The most recent arrival at the museum has been another tortoiseshell and white stray who turned up in the spring of 2004. She is called Chessie, named like the other feline residents, after a trolley car company – in this case, the Chesapeake Railroad.

Hotel cats

It has become something of a tradition to have a resident cat in various hotels around the world. Although initially, these may have helped with rodent control, the presence of a cat today essentially brings a homely feel to the hotel, and so may serve to attract guests. The Algonquin Hotel, located at 59 West 44th Street in Manhattan, New York, has a long-standing reputation, both as a venue for literary gatherings and also for its feline residents. The first official hotel cat was a tortoiseshell called Rusty, who moved into the hotel during the 1920s and enchanted the guests by reputedly drinking milk out of a champagne glass. The special cat door constructed for Rusty was used by subsequent feline residents and can still be seen at the hotel today. The resident cats traditionally sleep on a small chaise longue just inside the hotel's entrance.

Rusty's replacement was a blue and white tabby who simply wandered in off the streets, and was allowed to stay by the general manager and owner Frank Case. This cat became known as Hamlet, a theatrical name suggested by the actor John Barrymore, who was a frequent visitor to the hotel. It was reputedly during Hamlet's time at the Algonquin that one of the famous expressions about cats has its origins. The writer and socialite Dorothy Parker was asked how to kill a cat, she replied, 'Try curiosity', which has since become transposed into 'Curiosity killed the cat', reflecting the way in which cats will investigate new things in their surroundings.

Female cats at the Algonquin have traditionally been called Maltida. During the 1990s, the role of resident feline was filled by a stray. Unfortunately, in a sign of changing times, she suffered the indignity of being mugged for her distinctive collar, but was otherwise unaffected by this unpleasant experience. The present resident of the Algonquin is a illustrious pure-bred Ragdoll, one of the most docile of

112

all breeds, who assumed the post in 1997. The first pedigree cat to hold this post, she received the *Cat of the Year* award in 2006 and has built up a considerable worldwide fan base. In this modern age, she receives emails from around the world, and always closes her replies with the immortal words, 'Have a purrfect day'.

In London too, hotel cats were not unknown. One of the most notorious was Tiger who lived at the Ritz Hotel in London's Piccadilly. He was ostensibly resident to catch mice, being nicknamed 'The Terror of the Ritz', but in reality, he spent much of his time lounging around, relying on treats from guests and being spoilt by kitchen staff. He became so obese that he had to be sent away on an annual holiday to slim down.

Kaspar may not be a real hotel cat, but he is considered to be a very lucky one. He was first put on display at London's Savoy Hotel during the 1920s. Black in colour, he was carved by the designer Basil Ionides. Most of the time, Kaspar resided in a special display case, located opposite the gift shop, but occasionally he attended dinner parties at the hotel. This is because back in 1898, a South African businessman called Woolf Joel booked a dinner for fourteen people, but one of the guests was unable to attend at the last minute. Woolf laughed at the superstition that in a party of the unlucky number thirteen, the first person to rise after the meal would meet an inauspicious end.

Plenty of people remembered that, however, when Joel was found shot dead after returning home. In a bid to prevent further bad publicity, the Savoy decided to include a member of staff to make up the numbers whenever a booking for thirteen was received. This was not an ideal arrangement however, so they then came up with the enlightened solution of making Kaspar the honorary four-teen guest.

No-one objected to him being present, particularly since he could be relied upon to be completely discreet. He was

seated at the table, with the cutlery for each course laid out in front of him, and a napkin tied around his neck. But this is not to say that Kaspar has not had something of an adventurous life. He was once kidnapped by a group of Royal Air Force personnel and his release was negotiated by one of Britain's greatest Prime Ministers, Winston Churchill, who valued his company as a dinner guest. The Savoy closed for refurbishment in 2007 but Kaspar was kept safe and restored to his position when the hotel re-opened in 2009.

SECTION SIX

Famous Felines
An A-Z

Coding of symbols:-

= real life cat

 = fictional cat

 = cartoon cat

= musical cat

= amazing cat

A is for Am and Atossa

Ahmedabad

A cat belonging to the economist John Kenneth Galbraith (1908–2006), during the two years he served as the US ambassador to India, leaving in 1963. His insistence on calling his pet Ahmed upset Islamic members of his staff so he changed the cat's name to Gujarat.

Abby the Olympic Tabby

In an episode of television's *The Simpsons* cartoon series called 'The Old Man and the C Student', Homer Simpson decides to cover the family cat Snowball with papier-mâché to create a mascot (see also page 133 and **Snowball**).

Adolf

A cat which flew regularly with owner Ed Stelzig out of the airport at Darwin, Australia (see page 84).

All-ball

This was the first cat kept by Koko, a lowland gorilla born in 1971 who was able to use sign language and indicated to her trainer Dr. Francine Patterson in 1984 that she would like a cat as a companion. Koko herself chose and named All-ball from a litter of abandoned kittens. Interestingly, All-ball, who was coloured blue, had no tail but it was never clear whether this affected Koko's choice. But she cared devotedly for her new pet, treating it just like a baby gorilla. The experiment had a sad ending however, when All-ball ran out of their enclosure, and was hit and killed by a car.

When of All-ball's death, Koko's reaction was remarkable. She signed the words 'sad' and 'cry', provoking an

intense debate as to whether gorillas (and other great apes too) may feel emotions which were previously believed to be exclusively human. This remarkable story featured in Dr. Paterson's book *Koko's Kitten*, published in 1985. When she had the opportunity to choose another kitten, Koko picked out a cream-coloured individual called Lipstick, who was followed by a blue smoke individual also characterised by a Manx-like lack of a tail. Smokey formed a very close bond with Koko, but died of natural causes in 2004 (see **Principe**).

Allen
See **Woody** (page 209).

Am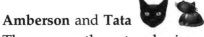
One half of the duo who performed the Siamese Cat song in *The Lady and the Tramp* (see under **Si** and **Am**, page 186).

Amber
Star of the film *The Cat from Outer Space*. The title role was shared between two Abyssinian cats, who were brother and sister.

Amberson and Tata
These were the cats who inspired cartoonist George Booth, whose work has appeared in *The New Yorker* and other publications, as well as books.

Ambrose
A cat who lived at the Theatre Royal, Drury Lane, London (see page 34).

Andy

He was a lucky cat owned by Ken Myer, a Florida senator during the 1970s. Andy's main claim to fame was that he survived a fall from the 16th floor of an apartment block without injury. A cat is very adept at landing on its feet after falling, which helps to protect from fatal injuries. But broken jaws are not uncommon, owing to the momentum with which they hit the ground. Their legs may serve as shock-absorbers, but the stress can result in pelvic fractures too.

Apollinaris

One of a number of cats kept by the American writer Mark Twain (see also **Buffalo Bill**, **Sour Mash**, **Zoraster**, and page 19).

Aristocats, The

An animated adventure released in 1970 by Walt Disney Productions, telling how a family of aristocratic cats are kidnapped by the butler to prevent them inheriting their mistress's fortune. The story is set in Paris during 1910, with the mother cat and her kittens helped by a street-wise alley cat, called Thomas O'Malley (see also **Berlioz**, **Duchess**, **Marie**, **Scat Cat** and **Toulouse**).

Arthur (1)

A white shorthaired cat, star of British television advertisements for cat food (see page 39).

Arthur (2)

One of the black cats included in the book *Twinkles, Arthur and Puss* by Judith Kerr (see **Mog**).

118

Asparagus

The formal name for **Gus, the Theatre Cat** (see page 147).

Atossa

The three-legged Persian kept by Matthew Arnold (1822–1888). Atossa's long-standing patience was described by Arnold in his poem about his canary entitled *Poor Matthias*. Atossa would spend many hours alongside the bird's cage, ever hopeful but never actually striking.

B is for Bagpuss and Button

Bagpuss

An elderly, saggy toy cat, Bagpuss featured in an English television series first broadcast in 1974, using stop-frame animation. Only thirteen episodes in total were produced, and originally, Bagpuss was to have been a ginger marmalade shade. The company dying the fabric made a mistake though, and so this is why he ended up with pink and cream stripes – according to his creator, Peter Firmin. Bagpuss can now be seen on display at the Rupert Bear Museum in Canterbury, Kent, and his enduring popularity can be gauged by the fact that in 1999, the series was voted the country's favourite children's television show in a poll organised by the BBC.

Barley

A cat kept at the Highland Park whisky distillery (see page 104).

Bast

A fictional character featuring in a number of Marvel Comics' stories and inspired by the feline goddess of the same name, which featured in Egyptian culture (see page 47).

BC

The theatre cat resident at the Oxford Playhouse (see page 34).

Beckoning Cat

A Japanese good luck symbol (see page 55).

Beerbohm

A cat who was resident at the Globe Theatre in London (see page 33).

Beethoven

One of six Himalayan/Colourpoint Longhairs kept by the American television personality and businesswoman Martha Stewart. Four of them – Beethoven, Mozart, Vivaldi and Verdi – are named after composers and live alongside the pair called Teeny and Weeny, which is a strange choice of names, given the relatively large size of this particular breed.

Behemoth

A huge black cat, said to be as large as a pig, who features in Mikhail Bulgakov's satirical novel about the stifling bureaucracy of the Soviet Union in the Stalinist era. Behemoth could stand on his hind legs, talk, and drink vodka. Although Bulgakov started this work in 1928, the book was finally completed by his wife after his death in 1940. It was not published in full until 1973.

Bendigo Bung-eye

A ginger and white one-eyed tabby cat who appears in Dick King-Smith's book *Saddlebottom*, published in 1985. Bendigo Bung-eye helps Saddlebottom, a Wessex Saddleback pig who has been rejected by his mother, Dorothea because his white saddle is not on his back, but over his hindquarters. Thanks to his friend's assistance, Saddlebottom soon becomes rich and famous.

Benny the Ball
(a.k.a. Benjamin T. 'Benny the Ball' Ball, Jr.)
One of Top Cat's closest associates, Benny is rather slow on the uptake, but often comes up with the most telling interventions in this cartoon series featuring a gang of New York alley cats (see **Top Cat**, page 201).

Beppo
A cat owned by Lord Byron (1788–1824) who also entertained a more exotic taste in pets – he kept a bear while at university in Cambridge. *Beppo* was the name Byron gave to a poem which he published in 1818, often called *The Venetian Story*, about a woman whose husband Beppo disappeared at sea three years earlier. 'Beppo' itself is an abbreviation for 'Giuseppe'. Byron often took his cats on his travels with him. He is known to have owned five in total.

Berlioz
One of the three kitten stars in *The Aristocats* (see page 23), released by Walt Disney Productions in 1970 (see also **Duchess**, **Marie**, **Scat Cat** and **Toulouse**).

Big Foot
It is not that uncommon for some cats to have extra toes on their feet. This is a condition known as polydactylism, and is especially prevalent in Siamese, running in families. Big Foot was a Siamese born in 1978 who lived in Wauchula, Florida and displayed this trait, having a total of 26 toes on her four feet. There were seven on each of her front feet and six on her hind feet. Both her mother and sister had 22, while her brother had 24 toes.

FAMOUS FELINES: AN A–Z

Binks

A tortoiseshell cat who wandered into Edward Bates's store as a kitten in 1921. The shop was well-known as a 'gentleman's hatter' and was located close to Piccadilly Circus in London. Binks was quite a character and very popular with customers. Sadly, he died unexpectedly when he was just five years old. He was stuffed and placed in a glass case, with a top hat on his head and a cheroot in his mouth. Since then, he has remained on display in the store where he spent virtually his entire life.

Blackjack

This individual is also more formally known as 'Cat 187'. Former model turned cat rescuer Celia Hammond was called in by the London Development Agency to remove stray cats living in the area of wasteland being redeveloped for the 2012 Olympic Games. The site extends over an area of 800 acres (3.24 sq km) in east London. Ceilia managed to trap 186 cats, but Blackjack, a black longhaired cat, constantly avoided every attempt to lure him away to a safer life and was the last cat left in the area. He was finally caught in a trap baited with roast chicken during July 2008, a year after he had first been sighted. It is suspected that he may have been an abandoned pet, rather than a feral cat, since he subsequently proved to be quite friendly.

Birdie

A cat kept by Tempe (Temperance) Brown, the forensic anthropologist in a series of novels written by Kathy Reichs, who shares her heroine's occupation.

Blackberry
The first **Munchkin** cat (see page 108).

Blackie (1)

A cat kept at the White House by Calvin Coolidge during his presidency in the 1920s (see also **Bounder, Climber a.k.a. Mud, Smokey** and **Tiger**, page 59).

Blackie (2)

An alternative name given to **Simon** (see page 68), because of his fur colour.

Blackwell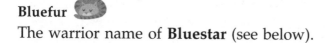

A cat taken to the Antarctic on Scott's first expedition, sailing on-board *Discovery* (see **Poplar** and page 76).

Bluefur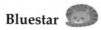

The warrior name of **Bluestar** (see below).

Bluestar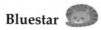

A ThunderClan cat who is mainly blue in colour, aside from an area of silvery fur around the muzzle. She has blue eyes and a scar on her shoulders. Bluestar secretly gave birth to Oakheart.

Bosch and Tommy

These were two cats kept by Anne Frank and her family during the Second World War when they hiding from the Nazis in a house in Amsterdam. The choice of names was not coincidental 'Bosch' was a slang term coined for the Germans in the Great War of 1914–1918, while 'Tommy' was a nickname given to British ground troops. Tommy always proved to be the stronger individual and beat Bosch in all fights.

Bouhaki

This may be the earliest recorded name given to a pet cat, the image of which forms part of an ancient Egyptian wall-carving. It is believed to date back to approximately 1950 BC, although the name could equally have been given to the dog that features in the same scene. If so, the next definite cat whose name is known is Nedjem (translating as 'Sweet'), who was alive during the reign of Thutmose III (1479–1425 BC).

Bounder

One of a group of cats owned by President Calvin Coolidge, which lived at the White house (see **Blackie**, **Climber a.k.a. Mud**, **Smokey** and **Tiger**, also page 60).

Boss Cat

The name under which the television cartoon series *Top Cat* (see page 201) was originally broadcast in 1962 in the UK. This change in name was deemed necessary because there was a 'Top Cat' cat food around then, Nevertheless, both the theme tune and the dialogue continued to refer to the main protagonist as Top Cat. It was not until 1999 that the series was broadcast in the UK for the first time under its original title, by which stage, the cat food itself had disappeared from the market.

Boy

A sealpoint Siamese kept by the actress Vivien Leigh (1913–1967), whose most famous role was probably as Scarlett O'Hara in the film *Gone with the Wind*.

Bowser

The Siamese cat kept by the short-sighted cartoon figure *Mr Magoo*, whose myopia leads him to believe that Bowser is in fact a dog. He was first seen on screen in 1949.

Bradley

A cat linked with Boston's Church of the Advent (see also **Jeoffry (2), Skippergee, Owl**, and page 97).

Brain

Orange cat Brain is unable to stop himself from blurting out the truth and is undoubtedly the least discreet member of **Top Cat's** gang (see page 23). He is also afflicted by a distinctive stutter.

Brobdingnagian

Described as being three times bigger than an ox, this massive, mythical cat featured in Jonathan Swift's 1726 book *Gulliver's Travels*.

Brooke

A working cat living at the Glenturret Distillery in Scotland (see also **Dylan, Towser** and page 103).

Brutus

See **Jack (2), Cleo (2)** and page 34.

Buffalo Bill

Named after the American folk hero, this was a cat kept by American writer Mark Twain (see also **Apollinaris, Sour Mash, Zoraster**, and page 19).

Burbank

The feline pet of Danny Glover in the film *Lethal Weapon*, which was released in 1987. Coincidentally, part of the filming was carried out at Burbank Studios, California.

Burmese Cat, The

A public house in Leicestershire, which was named by a cat-lover (see page 53).

Bustopher Jones

The highly social, fat cat in *Cats – the Musical* (see page 29).

Butch

A stray black cat, more streetwise than the leading feline character Tom, who appears in some episodes of **Tom and Jerry** (see page 148).

Butter cat

A cat of Norse mythology, said to bring butter with it (see page 46).

Button

The cat who undertook a remarkable car journey from England to Scotland and survived the experience (see page 85).

C is for Cheshire Cat and Crème Puff

Calvin

A tranquil blue cat who decided to adopt Harriet Beecher Stowe (1811–1896), the author of *Uncle Tom's Cabin*, and moved in with her. He learnt how to open door handles and always anticipated his meals which were shared with his adopted owner in the dining room. It was also not uncommon for him to sit on Harriet's shoulder for long periods while she was writing.

Captain

A cat resident in the grounds of Salisbury Cathedral (see also **Ginge, Tiddler** and **Wolfie**, and page 97).

Carbon Copy

An alternative name for CC, the world's first cloned pet cat (see **Copy Cat**).

Casey

A resident at Arkansas's Trolley Museum (see also **Chessie, Frisco, Katy** and **Smokey**, and page 111).

Catarina

A tortoiseshell cat kept by the mystery writer Edgar Allan Poe (1809–1849) and who provided the inspiration behind Poe's story *The Black Cat* , published in 1843, about called Pluto.

Cat in the Hat, The

A cat which keeps two children amused when they are left at home by their mother and it is raining outside. The story

Korky the Cat was one of the characters in *The Dandy* comics. This figure by Robert Harrop was based on an original 1974 cover. Korky the Cat appeared in the very first issue of the comic, on 4 December 1937.

THE Dandy BOOK 1974

2. Bast aka Bastet was an ancient Egyptian cat god.

The unnamed cat was one of four animals in the classic fairy tale, *The Town Musicians of Bremen*, told by the Grimm Brothers. After being mistreated by their masters they ran away, in search of Bremen which was known for its sense of freedom. En route, they frightened off four robbers and were commemorated by this 1953 statue which was erected in the German town, which they never actually reached. Several films, plays and TV programmes have been based on this famous tale, including *The Muppet Musicians of Bremen* by the late Jim Henson.

4. Beatrix Potter's eponymous Tom Kitten was made into a series of collectables, including this one by Beswick. Interestingly, whilst Tom Kitten is one of the most famous of literary cats, less people have read the book than recognise the character in his instantly recognisable blue suit.

5. Simpkin was the cat belonging to the tailor of Gloucester in the popular Beatrix Potter story based on the hard-working mouse. One of the lesser-known figures, this scarcity makes collectables, like this Beswick figure, harder to find and more desirable than more common portrayals such as Tom Kitten.

Dr Seuss' popular children's book, *The Cat in the Hat* was made into a film. Since it was first published in 1957, it has achieved cult status and toys, such as this vintage Impulse figure, have proved highly collectable.

7. Disney's infamous Siamese cats, Si (on the right) and Am appeared in *Lady and the Tramp* (1955). Both voiced by the songstress Peggy Lee, they represented

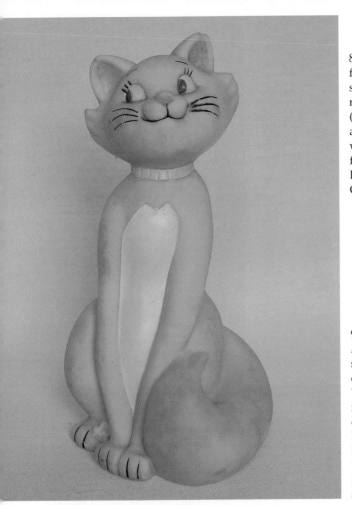

8. The quintessentially feline/
feminine side to cats can be
seen with Duchess, the sleek,
noble cat in Disney's *Aristocats*
(1970) who is befriended by the
alley cat, Thomas O'Malley
when misfortune befalls the
famous felines and her family.
Duchess was voiced by Eva
Gabor.

9. One of the regulars in *The
Huckleberry Hound Show* cartoon
series (1958–62), Mr Jinks was a
colourful cat who, like Tom in
Tom and Jerry, was at war with
mice – Pixie and Dixie in his
case. He was voiced by Daws
Butler who also voiced
Huckleberry Hound and Yogi
Bear, amongst others. Mr Jinks
is portrayed here as part of a
children's china set.

10. Felix is one of the most famous of all cats. Created by Otto Mesmer, he was first seen in 1919. Highly collectable, the once all-black cat has been turned into everything from matchstrikers to postcards and crockery, with frequent references to his walking, based on the 1923 song, 'Felix Kep on Walking'.

. Tom, of *Tom and Jerry* fame, is the most licensed of all cats, rtoon or otherwise. He can be seen on cake mixes, biscuits d a variety of sweets, as well as non-foodstuffs like this ntage pencil case. Tom also made the news when the cartoon ries was deemed 'too violent' for children.

12. Bagpuss, the 'saggy old cloth-cat', has long been a favourite on children's TV. He's also been made into a series of collectables by Robert Harrop, capturing the vibrant colours and cuddly shape of the classic cat.

3. The lazy but cunning comic strip cat has been turned into a TV series and animated film. His
distinctive colouring and mannerisms make him instantly recognisable. Garfield was produced as a
series of collectable figures by Enesco.

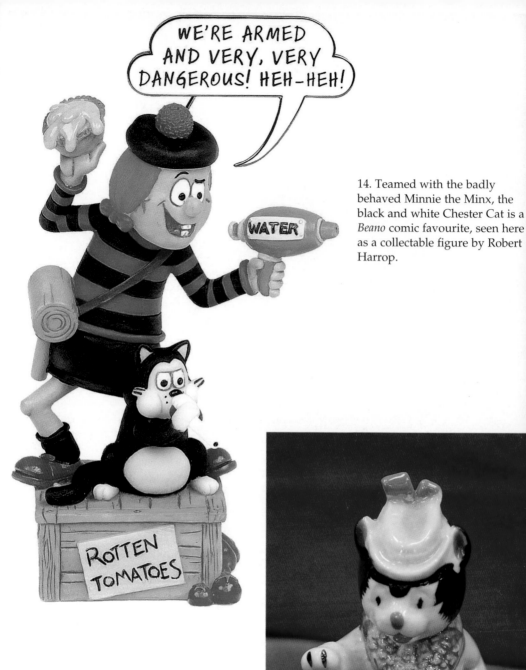

14. Teamed with the badly behaved Minnie the Minx, the black and white Chester Cat is a *Beano* comic favourite, seen here as a collectable figure by Robert Harrop.

15. The black and white cat in Enid Blyton's classic *Noddy* books, the anthropomorphic Miss Fluffy Cat, seen here as a Wade figure.

5. Jess, Postman Pat's black and white cat, used to go to work with the famous postman. Seen here a poster for a production starring some of children's favourite BBC characters.

17. Cats are popular figures in advertising and sales. This vintage Lucky Black Cat Perfume card still retains the original scent, the name suggesting that the wearer will have luck, playing on people's superstitions of lucky cats.

18. Hoffman's rice starch used cats as a marketing logo. This cut-out cat actually stands up, his front legs pulling forwards and would have been used in shops to advertise the brand. It wouldn't work in today's market. The red eyes would now denote a more devilish connotation, showing that the perception of cats in advertising has changed hugely in the last fifty years.

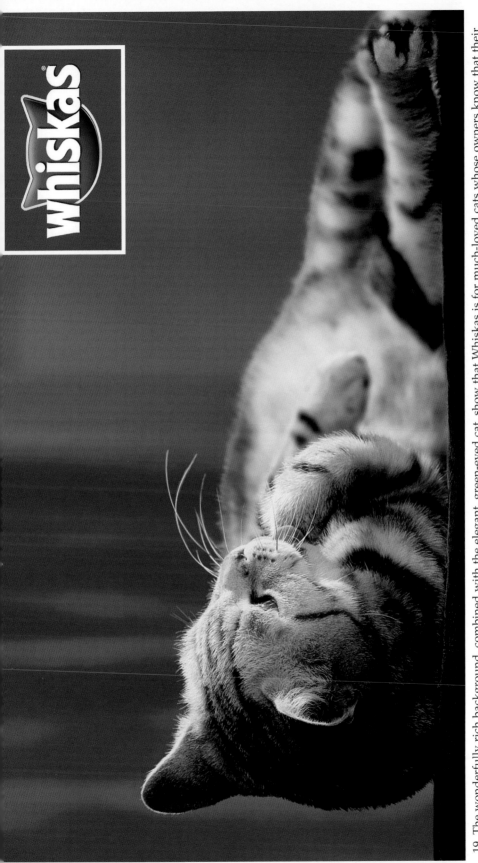

19. The wonderfully rich background, combined with the elegant, green-eyed cat, show that Whiskas is for much-loved cats whose owners know that their feline deserves the finest things in life. This clever marketing strategy has kept this well-established brand prominent in the cat food section over many years.

20. The Oriental Lucky Cat can be found in Japanese stores and homes, often with a beckoning paw. It is also known as the Maneki Neko, the Beckoning Cat, Welcoming Cat, Money Cat or Fortune Cat. It is traditionally portrayed as a Japanese Bobtail Cat. Interestingly, because of the difference in perception between the East and West, versions made for the western market will have the raised paw facing backwards so we understand that the cat is actually beckoning, not waving as the more traditional versions appears to western eyes. Either paw, or even both, can be raised.

21. Sanrio's most successful character, Hello Kitty, has a worldwide following based on a very simple but highly effective design.

was written by Dr. Seuss and appeared for the first time in 1957.

Cat Mandu

The pet of the founder of the Monster Raving Loony Party, Screaming Lord Sutch (see page 64).

Cats – The Musical

A musical created by Andrew Lloyd Webber, based on T.S. Eliot's *Old Possum's Book of Practical Cats* (see page 20). It premiered in London's West End on May 11, 1981 at the New London Theatre, and became proved to be a worldwide hit. Up until 2006, it held the record for the world's longest running musical. Additional characters in the musical include **Asparagus** 'The Other Cat' – a different cat from **Gus; Cassandra; Etcetera; Genghis**, (also spelt **Dschinghis**) **Grizabella; Jemima**, (known also as **Sillabub**) the magical **Mr. Mistoffelees; Pouncival; Tantomile** and **Victoria**. There may also be **Moushi** and **Pyewacket** (see page 178) from other books. Another character called **Carbucketty** appeared for a time in both the London and Broadway productions, but no longer features in the show.

Cattanooga Cats

An animated series created by the Hanna-Barbera studio, featuring the adventures of a feline rock band. It did not prove to be a success and was soon dropped, only running from 1969 until 1971.

Chanoine

See **Gavroche** (page 145).

Charo

A Persian cat kept by Yoko Ono, when she was married to Beatle John Lennon who was also a great cat-lover (see page 140). Charo may have been named after the Spanish entertainer who was very popular in America during the 1970s.

Cheshire Cat

This cat was created by Lewis Carroll, the pseudonym of Charles Dodgson. Characterised by its distinctive grin and its ability to appear and disappear unexpectedly, the Cheshire Cat originally featured in *Alice in Wonderland*. It was portrayed by the artist John Tenniel and has now become widely-used as a symbol. Back then, the inspiration for the image of the Cheshire Cat may have been based on that of a British Shorthair, which appeared in a grinning posture and served as an early trademark on Cheshire cheese.

Various other explanations may help to explain the cat's grin. There was a sign painter in Cheshire whose trademark was to decorate pub signs with grinning lions, and certainly the phrase about grinning like a Cheshire Cat was being widely-used in the area when Carroll was writing this book. Ecclesiastical influences may also have played a part, with some suggesting that a carving on a seat for the clergy at Croft Church could have provided inspiration. When seen from a pew, the cat appears to be grinning, but this facial expression seemingly disappears when you stand up. Finally, at Christ Church College, Oxford, where Dodgson studied, it is possible to see a trio of grinning animals present in the coat of arms of the Liddell family, possibly providing early inspiration for this now-famous feline.

Chessie

A sleeping kitten who was introduced in 1933 as the logo of the Chesapeake and Ohio Railway in the America. Travellers on these trains could, according to the company's slogan, 'sleep like a kitten and arrive as fresh as a daisy.' The name of the company was changed in 1972 to the Chessie System Railroad, suggesting the advertising had created a powerful image in the minds of customers. A merger then led to its disappearance in 1997 (see page 111).

Chester

A cat known under this pet name to his owner Professor Hetherington, but featured in scientific publications as the professor's co-author, under the name of F.D.C. Willard (see page 89)

Chloe

See **Demi** (page 136).

Choo Choo

Top Cat's second-in-command in the popular cartoon series. He is the tallest of the six gang members and often portrayed with slit-like Siamese eyes (see **Top Cat**, page 23).

Clarence

The longest cat on record who lived in Burnaby, British Columbia in Canada. Red in colour, he measured 41.5 in (105.4 cm) including his tail.

Clara

A cat associated with the Maritime Museum of the Atlantic in Nova Scotia (see also **Erik**, **Lady Bilgewater/Bertram Q. Bilgewater** and **Nannie**, and page 81).

Cleo (1)

One of a pair of cats kept by President Ronald Reagan during his tenure of the White House (see **Sara** and page 60).

Cleo (2)

A theatre cat from Shakespeare's Globe, also known under the stage of Portia, and sharing the limelight with **Jack** a.k.a. **Brutus** (see **Jack** and page 34).

Cléopatre

Another of the cats kept by Théophile Gautier (1811–1872) and which featured in his book *La Ménagerie Intime* (see page 162). She had a particular habit of standing on three legs.

Climber (a.k.a. **Mud**)

A Turkish Angora cat kept by US President Calvin Coolidge (see **Blackie**, **Bounder**, **Smokey**, **Tiger**, and page 60).

Cobby

A favourite feline companion of the novelist Thomas Hardy (see page 101).

Cody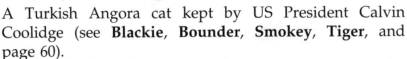

Some cats are seemingly immune to the appeal of classical music, but Cody was not amongst them. He reacted in a very affectionate way whenever his owner, composer Henri Sauguet (1901–1989) played Debussy on the piano. Studies of feline responses to particular notes, however, suggest that Sauguet's cat may have thought the composer

was in pain or simply distressed, and hence he rushed to lick him.

Colby

The cat who was awarded a degree (see page 91).

Coltrane – a.k.a. Snowball IV

He featured in the popular television cartoon series, *The Simpsons*. A white-coated cat rescued from an animal shelter, he was named after the jazz singer John Coltrane. Unfortunately, the sound of Lisa Simpson playing Coltrane's music on the saxophone caused him to jump out of a window to a premature end.

Cookie

The ninth of the Blue Peter cats to star in this long-running BBC television series for younger viewers, Cookie made his debut in September 2007. He arrived in the wake of a scandal over the naming of another cat, Socks. The producers acquired a second Ragdoll kitten called Cookie – the name the voting public originally wanted (see also **Jill, Jack, Kari, Oke, Socks** and **Smudge**).

Copy Cat

A white and brown tabby which was the world's first cloned cat, born on December 22, 2001. Although there had initially been 87 embryos prepared, only Copy Cat, or CC as she has become known, developed through to term. She was born at the College of Veterinary Medicine, at Texas A&M University, but now lives with one of the research scientists involved with the project. In September 2006, CC gave birth to three naturally sired kittens. This was a significant landmark, as it was the first occasion that

a cloned pet animal has produced young herself. Neither mother nor her offspring have shown signs of ill-health (see also **Little Nicky**).

Cowboy
The reputed favourite of President George W. Bush's three cats. Cowboy died from kidney disease aged 12 in February 2000 (see also page 61 and **Ernie 'Willie' Bush**, **India** and **'Willie' Bush**).

Crazy Christian
One of many cats kept by the writer Ernest Hemingway at his home on Cuba (see also **Friendless Brother** and page 92).

Crème Puff
Born in the city of Austin, Texas on August 3, 1967, she holds the record for being the oldest cat in the world. She died just three days after her 38th birthday. This compares with the typical maximum average life expectancy of pet cats today, which is around 15 years.

Crookshanks
A feline character created by J.K. Rowling, with his name meaning 'bent legs', as befits his bow-legged appeareance. Crookshanks first appears in the third book of the Harry Potter series, *Harry Potter and the Prisoner of Azkaban*. He is the pet of Hermione Granger, who becomes a close friend of Harry through successive books, and he was probably based on a Persian cat, thanks to his broad, flattened face. J.K. Rowling confirmed that the inspiration behind his appearance came from a real-life cat that she had seen. But Crookshanks was not just a cat – instead, he was part

Kneazle, which enabled him to detect people who were untrustworthy. Actress Evanna Lynch, a devoted fan, who subsequently took the film role of Luna Lovegood, had a cat which she named Crookshanks, but he died early in 2006, the year before the release of *Harry Potter and the Order of the Phoenix*.

Custard

The feline star of the cartoon series *Roobarb*, and subsequently *Roobarb and Custard Too*, Custard was first seen on BBC television in 1974. The series focuses on the interactions between Custard and his next door neighbour, a green dog called Roobarb. Custard's nature tends to be more cynical than that of the ever-enthusiastic Roobarb.

Other major participants in the drama are the Birds, who perch on a tree nearby, watching and commenting on the activities of Roobarb and Custard, as well as **Moggie Malone** (see page 167). There were thirty episodes produced in the first series, all animated by Bob Godfrey who was later responsible for **Henry's cat** (see page 148). What set these cartoons apart from those of the Hanna-Barbera studio such as **Tom and Jerry** (see page 198) was the very rough way in which the characters were sketched, but there was an accompanying phrenetic energy.

Such was the lasting popularity of Custard and his canine companion that they made a welcome return to British television in 2005, when Five commissioned a new series, with Custard now included in the title for the first time. These 39 episodes were screened from August 2005. All the attributes of the much-loved original were retained, but by computer animation this time, and to reinforce the sense of continuity, the scripts were again written by Grange Calveley, with the voices of the characters provided once more by Richard Briars.

D is for Debutante and Dylan

Debutante

A Sphynx cat owned by the villain Camille Leone, in the animated television series *Kim Possible*, about a teenage crime fighter of this name, which was first broadcast on the Disney channel in 2002. It ran for four series until 2007. Debutante was juxtaposed against Rufus, the naked mole-rat kept by Kimberley's boyfriend Ron Stoppable.

Delilah

A tortoiseshell cat who was the pet of Freddie Mercury (1946–1991), lead singer of the British rock band Queen. She was the subject of a song on the album *Innuendo*, which was released in the year of the singer's death. The lyrics clearly reveal that Deliah was not always clean around the home!

Demi

A black cat belonging to the former British Olympic hurdler and television sports presenter Sally Gunnell. She also owned a tabby cat called Chloe.

Dewey

A resident in Seymour Library, Auburn, New York State (see page 95).

Dewey Decimal (1)

Another cat, this time from Madison County, New York State, who spends his time in a library (see page 94).

Dewey Decimal (2)

A second, identically-named cat from Lake County, Florida (see page 95).

Dewey Readmore Books

The first cat of this name was originally a stray on the streets of Spencer, Iowa, before settling down as a library cat and ultimately selling his life story for a massive advance. This name, and variations on it, became very popular for cats in library circles because of the widely-used Dewey system for classifying books (see page 94).

Dinger

A female cat belonging to British rock singer Pete Doherty. She gave birth to five kittens in 2007. One of the cats fell ill, and tests by a vet allegedly showed it had ingested some cocaine powder. Dinger's name is slang for a syringe. After being jailed for drug abuse in 2008, Doherty declared how he had missed his cat while incarcerated. He has been known to take Dinger out with him when visiting a pub for a drink.

Disraeli

One of Florence Nightingale's many cats who were often named after famous statesmen. Florence grew up in a home full of animals and went on to spend the rest of her life in the company of cats – owning more than sixty in all and being devoted to every one. Despite the appalling conditions suffered while nursing injured soldiers during the Crimean War, Florence still found time to try to save a kitten she had been given. She eventually decided to send it home to England but sadly, the young cat died on the journey (see Mr. Bismarck).

Docket

A blue and white cat kept by artist Tracey Emin with whom he often sleeps. In the morning, he paws open the cupboard door where his food is kept.

Dolly

A cat kept by Tallulah Bankhead (1902–1968), the society beauty, party girl and American actress, whose life and career were frequently embroiled in controversy, largely because of her sexual appetites.

Domino

One of a number of cats owned by the New Zealand writer Margaret Mahy, whose children's books include *The Three-legged Cat*, published in 1993. Domino was a black and white cat, who gave birth to Orsino.

Don Pierrot de Navarre

Another feline owned by French writer Théophile Gautier. Don Pierrot was a white cat who gained a reputation for stealing the author's pens. He mated with Séraphita, who was also white, yet they produced three black kittens. These included Enjoras and Eponine, both of whom were named after character in *Les Misérables* (see page 162).

Doodles

The much-loved resident of the White Star liner *Cedric* (see page 82).

Duchess

The mother cat in the Walt Disney animated story *The Aristocats* (see page 23) who falls in love with Thomas

O'Malley, her streetwise saviour, who helps Duchess and her family to regain their rightful inheritance.

Dylan

Employed as a mouser at Scotland's Glenturret whisky distillery (see also **Towser** and **Brooke** and page 103).

E is for El Broosha and Erik

El Broosha

A fearsome huge black cat which features in the mythology of Spanish Jews which claims Adam had a previous wife, Lilith, before Eve. But she was not interested in Adam, and left Paradise transformed into a vampire. She is said to prey on infants and suck their blood at night, taking the form of *El Broosha*.

Elvis

Kept by John Lennon's mother – which may have encouraged the Beatle's life-long affection for felines. Named after Elvis Presley, this cat was never given a female name despite producing a litter of kittens in the family's kitchen cupboard (see page 130).

Erik

Found at the Maritime Museum of the Atlantic, Nova Scotia (see **Clara, Lady Bilgewater/Bertram Q. Bilgewater** and **Nannie,** and page 82).

Ernie 'Willie' Bush

One of President George W. Bush's three cats (see page 61, **Cowboy** and **India 'Willie' Bush**).

F is for Fancy-Fancy and Frisco

Faith

Lived at St. Augustine's and Faith's Church in Watling Street, London during the Blitz. Gave birth to a kitten called **Panda** (see page 99).

Fancy-Fancy

Something of a smooth operator who charms the lady cats he encounters. Fancy-Fancy is also a devoted member of Top Cat's gang, dashing off to join his mates when necessary. It is said his personality and voice were based on that of the actor Cary Grant (see **Top Cat**, page 201).

F.D.C. Willard

A Siamese with an unrivaled record for academic publications (see page 89).

Felix (1)

This famous cartoon cat dates back to the days of the silent movies when he was known as Master Tom. His screen debut was in a short film called *Feline Follies*, released by Paramount Studios in November 1919. It was not until three years later, in *Felix Saves The Day* that he was rechristened, and given a starring role. Felix's appearance then was quite different to the one we know now and he had a much thinner figure, pointed ears and a longer nose.

Before long however, he morphed into the more rotund, large-eyed cat who is instantly recognisable today. This fatter Felix meant he could be drawn more quickly in an era before computer animation which speeded up the production process and the growing number of cartoon

strips in which Felix featured. At the same time, as his profile grew, so he began to be used to advertise a wide range of different products, ranging from baby oil to clocks and toys. Felix – in the form of a toy – was the first character to be broadcast on the emerging medium of television in 1928. But soon his profile slipped as other cartoon rivals, notably Walt Disney's Mickey Mouse, emerged and started to talk on screen. By the time Felix was given a voice, it was too late, and he seemed destined for obscurity.

However, it was television which gave Felix a renaissance in front of a new audience. The original animation of Felix had been undertaken by Otto Messmer, and following his retirement in 1954, by his assistant Joe Oriolo. A reinvigorated Felix with a bag of tricks which gave him new powers, went on to star in over 250 television cartoon episodes. They featured new characters, one of whom – Master Cylinder the Robot – would never have been conceived when Felix was first seen on screen.

The first and only full-length feature film entitled *Felix the Cat: The Movie* followed, but proved a commercial disaster following its delayed release in 1991. But this has not killed off the Felix franchise, with a prequel television series, called *Baby Felix*, launched in 2000. There has also been a Nintendo game featuring this durable feline, now nearing his 90th year, who has become something of an entertainment icon.

Felix (2)
A French cat who was sent into space (see page 86).

Felix (3)
A cartoon cat used to promote a brand of cat food carrying his name (see page 43).

Fleur

The theatre cat from the Lyric Theatre, in London's West End (see page 33).

Fluffy

A resident of the Scilly Isles who was well-known for her fishing abilities there during the 1950s. Every night, this large black and white longhaired cat would wade into the sea, and wait for fish to come within reach. One night, she caught seven fish – largest over 1 ft (30 cm) long – and took them home to her owner. Fluffy was also a keen swimmer, unlike most cats. She thought nothing of swimming out to boats sometimes moored over 300 yds (275 m) from the shore.

Flypie

One of Queen Victoria's Persian cats, who ultimately passed into the care of her son Edward VII and Queen Alexandra. See White Heather (page 58).

Foss

A tabby owned by artist and writer Edward Lear (1812–1888). Foss was used as a model by Lear for his work, notably appearing in the cartoons illustrating *The Owl and the Pussycat* (see also page 36).

Frank

His recovery after a road traffic accident drew a worldwide internet audience (see page 126).

Frank Sinatra

One of two Siamese cats belonging to rap artist Snoop Dogg and commemorating the famous singer. The other is named after jazz supremo Miles Davis.

Freddie

One of a number of cats kept by Freddie Mercury, lead singer of the rock band Queen. Freddie was the inspiration behind the band's song *Delilah*, one of the tracks on the album *Innuendo*, released in 1991. Mercury's 1990 solo release *Mr Bad Guy* was dedicated to cat-lovers.

Friendless Brother

One of the cats kept by writer Ernest Hemingway (1899–1961) (see also **Crazy Christian** and page 92).

Frisco

Another cat from the Trolley Museum in Fort Smith, Arkansas (see **Casey**, **Chessie**, **Katy** and **Smokey** and page 111).

G is for Galinthias and Gros Minou

Galinthias

She was originally a servant to Princess Alcmene, according to Greek myth. She helped Alcmene give birth to her son Hercules, but Hera was furious because Hercules's father was her husband, Zeus. Hera therefore changed Galinthias into a cat, and exiled her to the underworld, where she became a priestess to Hecate, who was both queen of the witches and goddess of death. This helps to provide evidence of early links between cats and the occult, and especially witchcraft, which have lingered right through to the present day.

Garfield

This ultimate anti-hero is a creation of cartoonist Jim Davis and has build up an immense worldwide following. There are a number of anthropomorphic links apparent in Garfield's character. These include his dislike for Mondays and his extreme arachnophobia (fear of spiders) which is not a characteristic of true-life cats.

Gavroche

A Turkish Angora kept by Victor Hugo (1802–1885) and later renamed Chanoine, translating as 'the Canon', on account of his laziness.

George

The pet of the Dutch-American musician Eddie van Halen of the rock band van Halen.

Ginge

One of the cats who has resided at Salisbury Cathedral (see also **Captain**, **Tiddler** and **Wolfie**, and page 97).

Ginger

Featured in *The Tale of Ginger and Pickles* by Beatrix Potter (see page 21).

Golden Flower (*kinkwa-neko*)

The name given to red cats in Japan which could supposedly transform themselves into beautiful women and cause the downfall of powerful men.

Greebo

This cat appears in Terry Pratchett's *Discworld* novels. Greebo belongs to Nanny Ogg, the Lancre Witch. It is a blue British shorthair, also known as 'The Terror of the Ramtops'.

Griddlebone

A white Persian longhair who betrayed her suitor, **Growltiger** to a gang of Siamese cats in *Cats – the Musical*. One member of a triumverate of criminals (see page 30).

Grimalkin

This is a traditional English word for a grey (which is actually a blue) cat. It is sometimes used to describe an old cat too. There have been a number of individual cats – both real and fictional – who have been given this name. They have often been linked to some extent with the occult. Grimalkin was the name of the French seer Nostradamus and the witches' cat in *Macbeth*. The writer and poet John

Masefield (1878–1967) used a variation of this name – Greymalkin – as the name for one of three witches' cats in his children's book *The Midnight Folk* first published in 1927. The others were **Blackmalkin** and **Nibbins**.

Grizabella

The glamour cat featured in *Cats – the Musical* (see page 30).

Gros Minou

A ginger and white cat belonging to Canadian orthopaedic surgeon Dr. Eugene Trudeau. Gros Minou tumbled from the 20th floor penthouse in Outremont, Quebec Province, falling some 200 ft (61 m) to the ground, and survived in spite of sustaining a fractured pelvis.

Growltiger

A bruiser of a cat, who lived on a river barge travelling along the River Thames and who was in love with **Griddlebone**, one of the characters in *Cats – the Musical* (see page 30).

Gus

The Theatre Cat, fallen rather on hard times, in *Cats – the Musical*. His name is an abbreviated version of **Asparagus** (see page 119).

H is for Heathcliff and Humphrey

Hamlet (1)

Lived at the Algonquin Hotel, New York (see **Rusty** and **Maltida**, and page 112).

Hamlet (2)

Became a stowaway and travelled further by plane than any other cat (see page 83).

Heathcliff

Began life as a strip-cartoon figure in 1973. He was the creation of artist George Gately, and named after the character featured in Emily Bronte's novel, *Wuthering Heights*. Heathcliff's smart nature won him many fans, and by the early 1980s he was appearing worldwide in over 700 newspapers. He also featured in cartoons and books. Similar to Garfield in appearance, with his orange colour and black tabby markings, Heathcliff is far less indolent, but is a cat of fewer words overall. He is now portrayed in cartoon strip form by George Gately's nephew, Peter Gallagher.

Henry's Cat

A rather idle custard-yellow cat who was the star of a cartoon series released in the 1980s. It was produced by Bob Godfrey, who was responsible for *Roobarb* (see page 135). *Friends of Henry's Cat* included a pig called Pansy, and a blue rabbit called Chris. He ran into trouble with Constable Bulldog, however, and an evil sheep called Rum Baa Baa; not to mention Farmer Giles who was the only human featured. Henry himself was never seen – the name 'Henry's Cat' being a joke referring to a previous

collaboration between Godfrey and the writer Stan Hayward about a long-suffering commuter called Henry. In fact, there is no suggestion that the cat in this case has an owner at all. First shown in 1982, *Henry's Cat* ran for five series, with the episodes in series three onwards extended from five to fifteen minutes.

Hester and Sam

These were the pet cats of artist Andy Warhol (1928–1987), a great cat-lover, though this was not widely-known outside his immediate circle. All his cats were called Sam, which was a suitably gender-neutral name. Warhol often had to give away kittens to friends, to avoid being overrun by them. Hester was a one-off, reflected by the 'One Blue Pussy' in the title of his book. He privately published the book *25 Cats Name Sam and One Blue Pussy* in 1954, although in true Warhol style, there were just 16 such cats called Sam in it.

The calligraphy was undertaken by Warhol's mother, Julia Warhola. She forgot to add the 'd' to 'name' in the title, but Warhol decided not to change this, feeling it corresponded well with the imperfections created by the individual colouring of the book's pictures. Charles Lisanby is credited as the author, having proposed the title, although there is no text in the book. It was a limited edition work, with probably fewer than 150 being produced, which were given away as gifts by Warhol to his friends. He then produced another book self-published on the theme of cats, entitled *Holy Cats by Andy Warhol's Mother*.

The copies of *25 Cats Name Sam and One Blue Pussy* were numbered, and the fourth copy was presented to a woman called Geraldine Stutz, who was later to ensure the work reached a wider audience. She became head of an imprint of a major publishing house in New York, and used this copy to create a facsimile edition which was published in

1987 as part of a double set with *Hole Cats by Andy Warhol's Mother*. After Stutz's death, her original copy was sold at a New York auction for $35,000 (£17,000) in May 2006.

Hiddigeigei

A tom cat who contrasted his serene existence of contemplating the world with what he considered the pointless struggles of the people. He was the creation of poet Joseph Viktor von Scheffel (1826–1886) and appeared in his romantic and humorous work *Der Trompeter von Sackingen* (*The Trumpeter of Sackingen*). First published in 1853, it proved immensely popular and was published in over 250 editions.

Himmy

An Australian cat from Cairns in Queensland, Australia, who had the misfortune to be accorded the title of the heaviest cat in the world during the 1980s. He tipped the scales at almost 47 lb (21.3 kg) and died of respiratory failure in 1986.

Hinse

A ferocious tomcat owned by novelist Sir Walter Scott (1771–1832). He used to attack the writer's large hounds without fear of retribution until he encountered a bloodhound called Nimrod in 1826. The hound reacted violently and Hinse was killed in the resulting fight. This caused considerable distress to Scott, who had actually disliked cats before making Hinse's acquaintance.

Hodge

Beloved pet of the essayist Dr. Samuel Johnson (1709–1784). Johnson's biographer and friend James Boswell was a

confirmed cat-hater and marvelled at the attention lavished on Hodge. Johnson would go out to buy oysters for his pet (which were then a plentiful, cheap food) rather than send a servant, and was convinced that Hodge understood what he was saying. When Hodge died, Johnson's friend, the social reformer and poet Percival Stockdale (1736–1811) eulogised him in the work *An Elegy on the Death of Dr. Johnson's Favourite Cat*. Today, a bronze statue of Hodge which was unveiled in 1997 stands outside Dr. Johnson's home at 17, Gough Square in London. Aside from Hodge, Dr. Johnson also owned a cat called Lily, but she did not rank in the same way in the doctor's affections.

Humphrey

The successor to Downing Street cat Wilberforce. He took over in 1987 as the official feline resident at the Prime Minister's offices (see page 62).

I is for Indie Willie Bush

India 'Willie' Bush
Family pet of US president George W. Bush (see page 61).
(See also **Cowboy** and **Ernie 'Willie' Bush**.)

J is for Jellicles and Jill

Jack

First appeared with his sister Jill on *Blue Peter*, the long-running BBC children's magazine programme, in February 1976 when they were three weeks old. Both were silver; Jack a mackerel tabby, and Jill a spotted tabby. In contrast to Jason whom they replaced, neither Jack nor Jill cared greatly for the limelight and regularly jumped out of shot. Jack died unexpectedly when he was 10 years old (see also **Jason, Jill, Willow, Kari, Oke, Smudge, Socks** and **Cookie**).

Jack (2)

One of a duo from Shakespeare's Globe Theatre and also known as Brutus (see **Cleo**, and page 34).

Jason

The first cat ever to appear on the popular BBC children's programme *Blue Peter*, Jason, was a sealpoint Siamese who made his debut on the show with his mother and brother when he was just three weeks old in 1964. He regularly appeared on the show, even playing the role of the **Cheshire Cat** (see page 130) in a Christmas pantomime right at the end of his life in December 1975. He passed away early in 1976 (see also **Jill, Jack, Willow, Kari, Oke, Smudge, Socks** and **Cookie**).

Jellicles

A group of black and white cats created by T.S. Eliot, which feature in *Old Possum's Book of Practical Cats* (see page 171). They relaxed during the day and were lively at night (they were eager participants in the Jellicle Ball). In the stage version *Cats – the Musical* however, the Jellicles

occurred in a wider range of colours. They were led by **Old Deuteronomy** (see page 31).

Jellylorum

A tabby kept by T.S. Eliot (1888–1965) which provided inspiration for the series of poems *Old Possum's Book of Practical Cats* – and subsequently for the musical *Cats* by Andrew Lloyd Webber (see page 30).

Jennie Baldrin

The fictional creation of author Paul Gallico (1897–1976) (see page 22), Jennie was a tabby cat left to fend for herself by her family. She appeared in his novel originally called *Jennie*, which was published in North America as *The Abandoned* in 1950. Her role was to help a boy called Peter – who had been turned into a cat after a car accident – to behave in a suitably feline manner.

Jennyanydots

A tabby with stripes and spots who is a Gumbie Cat in *Cats – the Musical* (see page 30).

Jeoffry (1)

The beloved companion and sometime muse of English poet Christopher Smart (1722–1771). A brilliant scholar who had been appointed a Fellow of Pembroke College at Cambridge, Smart suffered severe financial problems and ended up suffering a serious nervous breakdown. He developed a religious mania and was confined to St. Luke's Hospital for Lunatics, a mental asylum in London for two years. Confined to a dark, tiny cell, Smart was helped through this awful period in his life by Jeoffry's companionship. He was then transferred to a private asylum in Bethnal

Green. It was here that he acknowledged the help that Jeoffry had given him in a section of his poem *Jubilate Agno*, entitled *For I Will Consider My Cat Jeoffry*. Remarkably, the poem never appeared during Smart's lifetime. It was only published for the first time in 1939, nearly 300 years after his death.

Jeoffry (2)

One of the resident cats from the Church of the Advent, Boston, America (see also **Bradley**, **Owl** and **Skippergee** and page 97).

Jezebel

A character in the **Skippyjon Jones** books (see page 187).

Jill

A silver spotted tabby and sister of **Jack** (see page 153). Both appeared regularly on BBC's *Blue Peter*. Jill gave birth to two kittens in 1980, and then died of heart failure three years later, aged seven (see also **Jack**, **Willow**, **Kari**, **Oke**, **Smudge**, **Socks** and **Cookie**).

Jillboo

Another sister of the Siamese fictional character, Skippyjon Jones (see page 187).

Jones

Another red tabby who found film stardom, Jones was the spaceship's cat in the highly-successful sci-fi horror movie *Alien*, directed by Ridley Scott. In the film, he was cared for by Brett, Chief Engineer aboard the *Nostromo*. Luckily, Jones survives the terrifying experiences which claim the lives of

most of the crew, and finally escapes in the company of Ellen Ripley, played by Sigourney Weaver.

Ju Ju Bee

Sister of the Siamese cat **Skippyjon Jones**, who has become very popular since 2003 as a children's fictional character (see page 187).

Junebug

Mother of the fictional Siamese cat called **Skippyjon Jones** created by American children's writer Judith Schachner.

K is for Kaspar and Kirlee

Kallibunker

Born in 1950 and the founder of the Cornish Rex breed. He was the first cat to display the unique coat of the breed (see page 106).

Kari

One of two abandoned tabby kittens who grew up together and were ultimately seen regularly on the children's TV programme *Blue Peter*. They were given their unusual names in 1991 after two *Blue Peter* presenters returned from Japan, where they had taken part in karaoke singing (see **Oke**, **Jill**, **Jack**, **Smudge**, **Socks** and **Cookie**). Kari retired from the show in 2004, and died two years later.

Karoun

The pet of French writer and artist Jean Cocteau (1889–1963) who regarded cats as the 'soul' of a home. Karoun was particularly special to Cocteau who called him the 'king of cats' and dedicated his work *Drôle de Ménage* to him.

Kaspar

A carved figure at London's Savoy Hotel where he was 'invited' to join diners (see page 113).

Katy (1)

A resident cat at Trolley Museum in Fort Smith, Arkansas, USA (see **Casey**, **Chessie**, **Frisco** and **Smokey**, and page 111).

Katy (2)

Grossly overweight cat living in Russia (see page 85).

Kiki-la-Doucette

A Turkish Angora cat owned by French writer Colette, who wrote about her pet's relationship with Toby, a French Bulldog (see page 19).

Kirlee

Born in 1960 and the founder of the Devon Rex breed. All today's examples of the breed around the world share their origins (see page 106).

Kit the Cat

A character created by children's writer Alison Maloney and brought to life in illustrated form by Maddy McClellan. Kit finds having to watch Flash the Fish a very frustrating experience and tries to plot his downfall, but is thwarted by Dig the Dog.

Koko

One of a duo of crime-fighting Siamese cats created by Lilian Jackson Braun. *The Cat Who* titles (which now number over 36 titles) had a tragic beginning with the author's real-life cat Koko dying in a fall from her apartment. The series started in 1966 with *The Cat Who Could Read Backwards* (see also **Yum Yum**).

Korky

This black cat appeared in a cartoon strip in the comic known as *The Dandy*, being portrayed on the cover of the first issue in December 1937. He remained as the front cover star right up until 1984. Korky's strip was included in the comic for a further 21 years, before he was retired, having appeared in each of the 3,294 issues up to that point. Almost a year later, in November 2005, Korky then made a brief reappearance in the publication, having been drawn on a computer for the first time.

L is for Lalage and Lucifer Sam

Lady Bilgewater/Bertram Q. Bilgewater
Another feline resident of Nova Scotia's Martime Museum of the Atlantic. In this case, the cat's name was changed once its correct gender had been established (see also **Clara, Erik, Nannie**, and page 81).

Lalage
A Siamese cat belonging to thriller writer Anthony Burgess (1917–1993). Lalage lived with him during his time in south-east Asia.

Le Docteur
See **Mysouff** (page 169).

Lily
Another of Dr. Johnson's cats – but not his favourite. That honour was reserved for **Hodge** (see page 150).

Lipstick
Lived for a time with Koko the gorilla at the Gorilla Foundation in Woodside, California in the USA (see **Allball** and **Principe**).

Little Dewey
See **Dewey** (page 94).

Little Nicky
The first cat cloned commercially by a California-based company called Genetic Savings and Clone, on behalf of a

Texan woman known simply as Julie to preserve her identity. She paid $50,000 (£25,000) to have the DNA of her Maine Coon, called **Nicky**, used in this procedure. She claims that Little Nicky, who was born in 2004, is very similar in behaviour and appearance to his ancestor, who had died the year before, aged seventeen years (see **Copy Cat**).

Lord Nelson

A cat belonging to and highly valued by Robert Southey (1774–1843), one of England's lesser known 'Lake Poets', eclipsed in this role by William Wordsworth and others. Southey awarded his pet ever more extravagant titles, in appreciation of his supreme rat-killing abilities.

Lucifer Sam

He was another Siamese cat, the subject of a track of this name recorded by rock group Pink Floyd. It featured on their debut album *The Piper at the Gates of Dawn*, released in 1969. Sam was actually the pet of vocalist Syd Barrett, with the song itself originally being titled *Percy the Ratcatcher*.

Luck

This was the name attributed rather ironically to the beloved black cat owned by King Charles I (1600–1649). When the cat died at court, Charles saw this as a sign of bad luck, which indeed, proved to be the case. Luck's demise was followed the next day by the king's arrest for treason and a trial which ultimately led to his execution.

Lucky

The name under which American cat food advertising star **Morris** was originally known (see **Morris** and page 40).

Lummo

Travelled by sea from Europe around the Falkland Islands (see page 78).

M is for Macavity and Mysouff

Macavity (1)

Elusive ginger tom who is a criminal mastermind, featured in *Cats – the Musical* (see page 31).

Macavity (2)

The nickname given to an odd-eyed white cat with a purple collar who took to riding a bus in the Midlands. This strange behaviour began in January 2007, when Macavity would climb on board the number 331 bus (always at the same stop) and travel from Walsall to Wolverhampton. He seemed to know exactly where he was going, hiding under the seat until the next stop, where he hopped off again – possibly with the intention of visiting the local fish and chip shop for a meal.

Macek

Nikola Testa's pet cat who helped in development of an electrical supply (see page 88).

Madame Théophile

A striking red and white bicolour with blue eyes, this was one of the cats owned by French author Théophile Gautier (1811–1872). He chose the name because she always shared his bed. Madame was a sensitive soul. She was upset whenever a female singer visited Gautier and hit the high notes – particularly a high A. This caused her to rush to place her paw over the woman's mouth, reacting in a way that a cat would do with a kitten uttering distress calls. Gautier himself investigated her behaviour by trying to conceal this particular note, but his cat was not fooled. Her response to the human voice was displayed in a different

context when she stalked a pet parrot in the home. The bird turned round and asked what she had eaten for breakfast. This was sufficient to cause Madame Théophile to flee under a nearby bed, where she remained for the rest of the day.

Maizie

A ship's cat who saw active service with the US navy in the Pacific during the Second World War. After being torpedoed, she spent nearly two days adrift with the six surviving crew members, keeping up their morale before they were rescued.

Maltida

The name given to feline cats resident at New York's Algonquin Hotel (see also **Hamlet** and **Rusty**, and page 112).

Marcus

A Siamese cat owned by the actor James Dean (1931–1955), having been given to him as a present by Elizabeth Taylor. Dean named the cat after his uncle, Marcus Winslow, who helped to raise him after his mother's death.

Marie

A kitten in theThe Aristocats (see page 23). (See also **Berlioz, Duchess, Scat Cat** and **Toulouse**.)

Marilyn

A cat based at London's Comedy Theatre, Westminster, with fellow feline **Vivian** (see **Vivian** and page 34).

Marilyn Miste
Pet of American singer and actress Whitney Houston.

Master's Cat, The
One of the kittens born to **Williamina**, a cat owned by author Charles Dickens (see **Williamina** page 208). The birth was turned into a story by Eleanor Poe Barlow in 1998 and revealed Dickens through his pet's eyes.

McCavity
A cat who walked almost the length of Britain (see page 87).

Micetto
Born in the Vatican, this tabby became a very close companion of Pope Leo XII (1760–1829), following his election to the papacy in 1823.

Midnight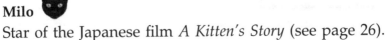
Saved the life of a child afflicted by a serious viral infection, by miaowing into the baby monitor, summoning her parents to help.

Milo
Star of the Japanese film *A Kitten's Story* (see page 26).

Minna Minna Mowbray
A tortoiseshell tabby and white cat owned by the British publisher Michael Joseph (1897–1958). This variety of cat is better known as a torbie and white in North America.

Miles Davis

The name chosen by rap artist Snoop Dogg for his cat in memory of American jazz legend who died in 1991 (see **also Sinatra, Frank**).

Miss. de Presto

The founder of the Selkirk Rex breed (see page 107).

Mrs. Chippy

A cat taken to the Antarctic on board Ernest Shackleton's ship *Endurance* (see page 77).

Mrs. Poodles

The first Siamese seen at a cat show in England in 1871.

Mrs. Whiskerson

The name given to the Sphynx cat bought by Rachel Green (played by Jennifer Aniston) in an episode of the American TV comedy series *Friends*. The cat's lack of hair was not appreciated by friends Joey and Ross. The episode was called *The One with the Ball* and was broadcast originally in the fifth series in 1999.

Mr. Bigglesworth

The cast name given to the Sphynx cat who appeared in the Austin Powers' film as Dr. Evil's cat – an ironic reference to the Bond villain Blofeld and his Persian cats. The official cattery name of the feline actor is SGC Belfry Ted Nude-Gent, although he is known to close associates, including his agent, as Ted.

Mr. Bismarck

A large Persian cat, named after the famous Prussian general and a particular favourite of the nurse Florence Nightingale (1820–1910). She described Mr. Bismarck as being a particularly gentle individual with a highly affectionate nature. He was always given some rice pudding, which he particularly liked, with his tea at 5pm every day. All Florence's cats were fed individually on fresh food served on china plates. They brought her great comfort, particularly after her return to London following the Crimean War, when her own health was poor (see **Disraeli**).

Mr. Mistoffelees

One of the cats featured in *Cats – The Musical*, as the small, black individual recognised for his conjuring skills (see page 31). His name is sometimes spelt Mr. Mistoffelees, although this does not correspond to the spelling of his name in the production.

Misty Malarky Ying Yang

The sealpoint Siamese who was a pet of Amy Carter when she was a child growing up in the White House, while her father was president (see page 60).

Mitsou

An exotic white Persian longhair, who was the beloved pet of Marilyn Monroe (1926–1962) when she was living in an apartment at the Waldorf-Astoria Towers, New York, during the mid-1950s. She also owned a blue kitten.

Mittens

The sister of **Tom Kitten**, created by Beatrix Potter (see page 20).

Famous Felines: An A–Z

Mog (1)

Featured in a series of children's books, as part of a dog-cat duo known as Meg and Mog, created by Jan Pieñkowski and Helen Nicoll. There are currently sixteen books in the series, four of which were used to form the basis of a theatrical production – *The Meg and Mog Show*. The characters have also starred in an animated television series commissioned by Children's ITV (cITV).

Mog (2)

A blue tabby and white cat created by Judith Kerr which featured in a series of adventures for younger readers, with the first story published in 1970. The last volume, *Goodbye, Mog*, appeared in 2002 and covered the rather controversial topic of Mog's death in a sensitive way that children could comprehend, helping them to come to terms with the death of a favourite pet.

Moggie Malone

A character from the television cartoon series originally called *Roobarb*, Moggie Malone is addicted to music of any kind, and is very willing to share what she sees as her vocal prowess through the neighbourhood. Unfortunately, her talent is not widely-apparent, but she has a great sense of humour, in contrast to Custard's pessimism (see **Custard**).

Moppet

Sister of Tom Kitten, Moppet also is the central character in one of Beatrix Potter's less well-known works, *The Story of Moppet* (see also **Tom Kitten (1)** and page 20).

Morris I

A ginger stray who found fame on American television advertising cat food (see page 40).

Morris II

The successor in the media spotlight to **Morris I**. He looked almost identical (see page 40).

Mourka

A stray cat adopted by the Russian gun crew during the Battle of Stalingrad, which lasted from August 1942–February 1943. He could be relied upon to deliver messages to headquarters and was rewarded with a meal, but it is thought unlikely that he survived this savage conflict.

Mouche

A cat owned by French novelist Victor Hugo (1802–1885) (see also **Gavroche** and **Chanoine**).

Moumoutte Blanche and Moumoutte Chinoise

These two cats were owned by the French novelist Pierre Loti (1850–1923). Blanche, a black and white Angora, was a long-standing pet and took exception to the introduction of Chinoise to their lives. She was a kitten who was a stowaway on the boat from China, on which Loi travelled home. The cats fought so viciously when they were first introduced that the only way to separate them was by pouring water over them. They then settled down and lived in complete harmony. They formed the subject of Loti's book, illustrated by C.E. Allen, which was first published in English as *Lives of Two Cats* in 1900.

Mozart

One of Martha Stewart's Himalayan/Colourpoint Longhair cats, the majority of which are named after famous composers (see **Beethoven**).

Muezza

The cat kept by the prophet Mohammed (see page 98).

Mungojerrie and Rumpelteazer

A lively couple of inseparable cats who are often seeking to steal food or knock over vases around the home. Together long with **Griddlebone** (see page 30) they formed part of an organised crime ring run by **Macavity** (see page 31). They feature in *Cats – the Musical* (see page 28).

Munchkin

A breed of cat distinguished by its short legs (see page 108).

Munich Mouser

A cat who was resident at Downing Street when Neville Chamberlain was Prime Minister in the 1930s (see page 62).

Mysouff

These were actually two cats, sometimes designated by the numbers I and II, which were owned by the French writer Alexandre Dumas (1802–1870), whose best-known work was *The Three Musketeers*. He also owned another cat called **Le Docteur.**

N is for Napoleon of Crime and Nemo

Nannie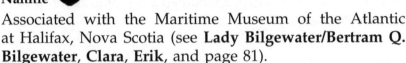

Associated with the Maritime Museum of the Atlantic at Halifax, Nova Scotia (see **Lady Bilgewater/Bertram Q. Bilgewater, Clara, Erik,** and page 81).

Nansen

Resident cat aboard the Belgian vessel *Belica* (see page 78).

Napoleon of Crime

Nickname given to **Macavity** (see page 164), feline criminal mastermind and counterpart of Professor Moriarty, the villain created by Sir Arthur Conan Doyle in *The Adventures of Sherlock Holmes*.

Nemo

Siamese cat which belonged to British Prime Minister Harold Wilson (1916–1995) and his wife Mary. They used to travel with Nemo on holiday, including to the Scilly Isles, in the days when quarantine regulations meant cats being brought from abroad had to go into quarantine for six months, because of fears over rabies.

O is for Old Deuteronomy and Owl

Oke

An abandoned kitten discovered under a bush, who grew up with a foster mother, alongside another kitten called **Kari** and went on to appear on BBC's *Blue Peter* from 1991 to 2004, before retiring at the age of 14 years old (see **Kari, Jill, Jack, Smudge, Socks** and **Cookie**).

Old Deuteronomy

As his name suggests, an elderly cat who features in *Cats – the Musical*. He is the patriarch of the **Jellicle** clan and has many descendants (see page 29). He ends up being kidnapped by **Macavity** (see page 31).

Old Gumbie

A type of cat, typified by **Jennyanydots** (see page 30) from *Cats – the Musical*, who sits quietly during the day and seeks out warm spots. Old Gumbie rounds up mice and other creatures such as cockroaches at night, attempting to transform them into useful citizens.

Old Possum's Book of Practical Cats

T.S. Eliot (1888–1965) wrote *Old Possum's Book of Practical Cats* as a set of poems, investigating social interactions between a group of cats. The first edition was published in 1939, and illustrated by Eliot himself, but a further edition released during the following year contained the humorous drawings of British illustrator Nicolas Bentley. The cast of cats appearing in Eliot's work, in alphabetical order are as follows:-

Admetus; Alonzo; Augustus; Bill Bailey; Bombalurina; Bustopher Jones; Cat Morgan; Coriopat; Demeter;

Electra; George; Gilbert; Great Rumpus Cat; Griddle-bone; Growltiger; Grumbuskin; Gus (an abbreviation for Asparagus): James; Jellylorum; Jennyanydots; Jonathan; Macavity; Mr. Mistoffelees; Mungojerrie; Munkustrap; Old Deuteronomy; Oopsa Cat (= James Buz-James); Peter; Plato; Quaxo; The Rum Tum Tugger; Rumpelteazer (in the book, but not *Cats – the Musical* where it is Rumpleteazer); Skimbleshanks, the Railway Cat; Tumblebrutus; Victor.

Six of the original 14 poems were then developed by the composer Alan Rawsthorne, to be recorded with an orchestral backing. This ultimately provided the inspiration for Andrew Lloyd Webber to develop *Cats – The Musical*, featuring extra feline characters that had been included in T.S. Eliot's original drafts (see *Cats – The Musical*).

Old Slowly

A rescue cat that saved a child from dying of hypothermia (see page 71).

Orangey

A red tabby who starred in a number of successful films, beginning with *Rhubarb* (see page 25).

Orlando

Often described also as Orlando the Marmalade Cat, because of his orange coloration, he was the creation of Kathleen Hale (1898–2000), an illustrator and children's writer. She produced a series of 19 adventures involving Orlando, which were published between 1938 and 1972. He lived in a town called Owlbarrow, which was actually the Suffolk town of Aldeburgh, with a number of the town's landmarks being featured in the book's illustrations.

Orsino
See **Domino** (page 138).

Oscar
Tabby and white cat who attracted worldwide attention because of his seeming ability to be able to predict when patients were going to die at the Steere House Nursing and Rehabilitation Center in Providence, Rhode Island where he was resident. Oscar would curl up alongside them, with death typically following two to four hours later – even if this was not anticipated by medical staff. Oscar stayed with each patient throughout this period, effectively ensuring that they did not pass away alone, although normally, he was not a particularly affectionate cat. He allegedly predicted more than 25 deaths in this way and with such accuracy that his case was written up and published by the *New England Journal of Medicine* during 2007. Oscar was given an award, in the form of a commemorative plaque, for his compassion and devotion. The general view is that perhaps Oscar may detect particular chemicals that are released by the body in the period immediately before death, and that he has become conditioned to recognise these, having grown up at the center.

Owl
A cat from the Church of the Advent in Boston, Massachusetts (see also **Bradley, Jeoffry (2)** and **Skipper-gee**, and page 98).

P is for Patripatan and Principe

Page Turner

A cat living in a library in Lake County, Florida (see page 93).

Panda

A kitten born to a London church cat called **Faith** during the Second World War (see **Faith** and page 99).

Pangur Ban

A white cat who lived during the 800s at the Abbey of St Paul, Reichenau Island in Lake Constance, between Germany and Austria, where he proved his worth as a skilled mouser. The story of his life was recorded in a poem written by his anonymous owner, an Irish Benedictine monk in the margins of an illuminated manuscript.

Patripatan

From south-east Asian mythology. There are several versions of this cat's story, but in all cases, he climbed up to heaven, in search of a flower. He failed to return for three centuries however, but found the country and his people were as young as they had been when he left.

Patsy

Pet of the pioneering American aviator Charles Lindbergh (1902–1974), Patsy was a blue cat who had been found as a stray in an aircraft hangar. She would fly with him on occasions, but contrary to popular belief, Lindbergh

claimed that she was not with him when he undertook his pioneering transatlantic flight in May 1927 making the first nonstop flight from Paris to New York in the *Spirit of St. Louis*.

Pepper

The first feline film star who appeared in silent movies of the early 1900s (see page 25).

Percy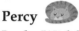

Lady Widdrington's cat in the P.G. Wodehouse short story *Cats will be Cats*.

Persian

A character from the Pokémon video game-based media franchise owned by Nintendo, Persian is portrayed in the guise of a Siamese cat. The Pokémon concept was launched during 1996 in Japan, and has become a worldwide phenomenon, spawning not just games, but cards, books and other merchandise showing the characters. Persian developed from **Meowth,** who is one of the few characters with the power of speech.

Peter I, II and III

A cat of this name was first employed in Britain's Home Office back in 1929, and remained in residence until 1946, when ill-health meant that he had to be put to sleep, aged 17 years. Unfortunately, his successor, also called Peter ended up being fatally injured in a road accident in Whitehall. A third cat, who joined as a kitten, continued in the post up until March 1964 (see also **Petra** and page 62).

Peter, the Lord's cat

Lived at the famous Lord's Cricket ground, between 1952 and 1964 and was nicknamed the 'Marylebone mog', because the ground is owned by the M.C.C. – the Marylebone Cricket Club. Following Peter's demise, his obituary was published in the *Wisden Cricketers' Almanac* in the following year. He is the only cat – and indeed animal – to be honoured in this way in the publication's history, which dates back to 1864. In 2006, Peter featured in a separate book, *Peter the Lord's Cat And Other Unexpected Obituaries*, based on records in *Wisden*.

Petra

The female kitten who lived at the Home Office and who took over from the male dynasty of cats called Peter. She was a tail-less Manx cat, donated by Sir Ronald Garvey, the Lieutenant-Governor of the Isle of Man. Unfortunately, she was much lazier in the post than her predecessors, and there was talk of retiring her prematurely. A memo written in 1969, which was released with other government papers in 2005, rejected this possibility however, highlighting the risk of adverse publicity. It appears that ultimately, Petra did retire though, as by 1976 she was no longer in her post, but living with a member of the Home Office's staff.

Pinky

A cat with the longest tail ever recorded. The appendage of this feline resident of Southgate in London measured 14 in (35.5 cm).

Pluto

The subject of Edgar Allan Poe's powerful short story *The Black Cat* which was published in *The Saturday Evening Post*

in 1843. It is a dark story of cruelty and betrayal, in which the cat plays a central role. The use of a black cat revisits superstitions about cats of this colour, and links to witchcraft. It was inspired by Poe's cat **Catarina** (see page 128).

Poplar

A black cat who journeyed to the Antarctic with Captain Scott and his crew (see **Blackwell** and page 76).

Portia

See **Cleo (2)**, **Jack (2)**, and page 34.

Princess Truman Tao-Tai

The most travelled sea cat, certainly of modern times, who spent almost her entire life on the world's oceans (see page 82).

Principe

Pet kitten adopted by a gorilla called Toto (1931–1968), who had been orphaned and raised by hand. This affliation began when Toto was about four years old, and she carried Principe everywhere with her (see **All-ball**).

Puss

A black cat who features in the Judith Kerr story *Twinkles, Arthur and Puss* for young readers (see **Twinkles**).

Puss-in-Boots

A traditional character, best-known from the story written by Charles Perrault (see page 16).

Pyewacket

The feline character who appears in the light-hearted film comedy *Bell, Book and Candle*, which was released by Columbia Pictures in 1958. It starred James Stewart and Kim Novak, with Pyewacket's role being that of a witch's familiar (see page 178). The name 'Pyewacket' was used in this context back in the 1640s by Matthew Hopkins, who served as the self-proclaimed Witchfinder General in England, hunting down witches, although it was not linked with the image of a cat at that stage, but that of a mysterious imp.

Q is for Questie

Questie

Ship's cat who travelled to the Antarctic on Ernest Shackleton's final voyage in 1921 (see page 78).

R is for Rap Cat and Rybolov

Rap Cat

A puppet cat used at chain of drive-through fast food restaurants in America to encourage customers to take the left side rather than the right. A controversial note to this campaign has been the way in which the chain has produced takeaway bags for cheeseburgers corresponding to Rap Cat's clothing. They have suggested that by cutting open these bags, they can then be converted into clothing for cats, allowing them to resemble Rap Cat. Using modern marketing techniques incorporating the internet, an online music video of Rap Cat was released in March 2007.

Red

Tabby cat owned by David Harper, a wealthy Canadian bachelor. When Harper died in March 2005, Red, then aged three, inherited his fortune of $1.3 million Canadian dollars. It fell to the United Church of Canada to ensure that all his future needs are met out of his inheritance.

Remark the Cat

Seen in *Cats – the Musical*, being the antithesis of **Grizabella** (see page 30).

Reverend Sir John Langbourne, D.D., The

Originally called simply Langbourne, this cat's name evolved over time, until not only did he end up with a knighthood but also became a Doctor of Divinity too. He lived with the philosopher and reformer Jeremy Bentham (1748–1832).

Roobarb
A British cartoon series featuring a cat called **Custard** (see page 135).

Royal Reggie
A resident cat at the Bryant Public Library, Minnesota in America (see **Dewey Readmore Books** and page 94).

Rumpelteazer
Appears in *Cats – the Musical*. See **Mungojerrie** and **Rumpelteazer** (see page 31).

Rum Tum Tugger
A rather contrary and curious cat, considered to be something of a nuisance in *Cats – the Musical* (see page 34).

Rupi
Belonged to Ian Anderson, founder of the UK rock band, Jethro Tull. He provided the inspiration for the album of that name, released by Ian in 2004.

Rusik
Crime-fighting cat involved in the front-line battle against caviar smugglers in the sturgeon's breeding grounds around the Caspian Sea (see page 73).

Rusty
Feline resident at the Algonquin Hotel in New York (see **Hamlet** and **Maltida**, and page 112).

Rybolov

One of the much-loved cats owned by the Russian composer Alexander Borodin (1833–1887) and his wife. This cat's name means 'fisherman', and refers to the cat's habit of catching fish through holes in the ice when the weather was freezing.

S is for Salem Saberhagen and Sybil

Saha

A member of the **Chartreux** breed who features in the French writer Colette's novel entitled *La Chatte* (see page 19).

Salem Saberhagen

The black cat which appeared in every episode of the television programme *Sabrina, The Teenage Witch* which ran from 1996 to 2003, and the three associated made-for-TV movies. According to the storyline, Salem was actually a 500 year-old warlock who had tried to take over the world, and as punishment, had been sentenced to spend a century in the guise of a cat. This part was voiced in every show by Nick Bakay with Salem being played by both animatronic and real black cats.

Sam (1)

See **Hester** (page 149).

Sam (2)

Associated with New Hall College, part of the University of Cambridge (see page 95). (Following a decision taken in June 2008, this college was renamed Murray Edwards College).

Sampson

A friendly ginger and white tabby cat in the *Church Mice* books written by Graham Oakley. Sampson lives in a church with a lonely mouse, who decides that the other mice in the neighbourhood should move in with him and they have many adventures. This long-running series began in the 1970s, with the most recent addition being *The Church Mice*

Take a Break, which was published in 2000. The story is set away from the church, when Sampson and the Church Mice find themselves lost, having accompanied the parson on holiday, unbeknown to him.

Sara

Lived with American President Ronald Reagan (1911–2004) at the White House during the 1980s, along with another cat called **Cleo** (see pages 132 and 60).

Sarah Snow

Sometimes also referred to as the 'Hertfordshire White' by her owner, writer Kingsley Amis (1922–1995), she was almost certainly a Turkish Angora with brilliant green eyes. Amis considered cats to be good for their owners' imaginations. He was fascinated by the thought that Sarah Snow might want to learn English. In fact, he wrote a poem on this theme, called *Cat-English*. Amis also believed that cat-owners had more gentle natures than those without cats.

Sassy

A Himalayan/colorpoint longhaired cat who appeared in the Walt Disney film *Homeward Bound: The Incredible Journey* in 1993. This was a remake of Sheila Burnford's best-selling novel *The Incredible Journey*, and generated over $40 million (£20 million) at the box office. This success led to a sequel, *Homeward Bound II : Lost in San Francisco*, which was actually filmed in localities around Oregon. Aside from Sassy herself, both the dogs cast in these films – a golden retriever and an American bulldog – were also slightly removed from the Labrador retriever and English bull terrier which featured in the original story (see **Tao**).

Scat Cat

A feline band leader who appears with fellow musicians in *The Aristocats* (see page 23). (See also **Berlioz, Duchess, Marie** and **Toulouse**.)

Schrodinger's cat

Not a cat at all, but a theoretical discussion of quantum mechanics (see page 90).

Sedgewick

This troublesome tom cat caused a major incident when he strayed into an electrical substation close to his home in Cambridgeshire in 1982. He received a shock of 33,000 volts, and blacked out 40,000 homes, but remarkably, survived the incident. He ended up making a full recovery, in spite of being badly singed by the experience.

Selma

A tortoiseshell and white tabby who was a favourite of the British statesman Horace Walpole (1717–1797). Her tragic death prompted Walpole's close friend, the poet Thomas Gray (1716–1771) to write *Ode on the Death of a Favourite Cat, drowned in a Tub of Goldfishes*. Walpole was one of the first to keep these fish in Europe (see also **Zara**).

Shan Shein

Siamese cat kept by Susan, the daughter of American President Gerald Ford (1913–2006) (see also page 60).

Shulamith

The founder of the American Curl bloodline, back in 1981 (see page 107).

Si and Am

The Siamese cats who appeared in Walt Disney's *The Lady and the Tramp*, and perhaps best remembered for singing the *Siamese Cat Song*. It was written by Sonny Burke, and Peggy Lee (who sung it in the film).

Siam

First Siamese cat ever seen in America (see page 61).

Simon

The only cat to receive the Dickin Medal during the Second World War (1939–1945) (see **Blackie** and page 68).

Simpkin

A cat in the Beatrix Potter story *The Tailor of Gloucester* (see also page 20).

Simpkins

Resident cat at Hertford College's library at the Oxford University (see page 95).

Sinh

A fabled example of the **Birman** breed (see page 109).

Skimbleshanks

The railway cat from *Cats – the Musical*, who travelled from station to station (see page 32).

Skippergee

A tortoiseshell and white cat resident at the Church of the Advent in Boston, Massachusetts (see page 98).

Skippyjon Jones

A character created by children's writer Judith Bryon Schachner. Skippyjon Jones is a Siamese cat with larger than normal ears so he looks rather like a Chihuahua dog. He has three sisters called **Jezebel**, **Jillboo** and **Ju Ju Bee**, and they all live with their mother **Junebug**. This picture book won numerous awards since publication in 2003, and further stories Skippyjon Jones's adventures followed.

Slippers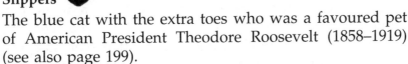

The blue cat with the extra toes who was a favoured pet of American President Theodore Roosevelt (1858–1919) (see also page 199).

Smokey(1)

One of a number of cats kept by American President Calvin Coolidge at the White House (see also **Blackie**, **Bounder**, **Climber** a.k.a. **Mud**, and **Tiger**, and page 59).

Smokey (2)

Resident at the Trolley Museum in Fort Smith, Arkansas (see also **Casey**, **Chessie**, **Frisco** and **Katy**, and page 111).

Smoky

Spent his entire life with Koko the gorilla in California (see **All-ball** and **Principe**).

Smudge

A young cat who appeared briefly on *Blue Peter*, taking over from **Kari** and **Oke** who retired in 2004. Sadly, Smudge met a premature end after being run over near his home the following year before his first birthday (see also **Jill**, **Jack**, **Kari**, **Oke**, **Socks** and **Cookie**).

Snooks

The kitten to which all Scottish folds trace their ancestry (see **Susie** and also page 107).

Snowball (1)

There have been five cats of this name which have appeared – usually only briefly – in the popular television series *The Simpsons*. The first Snowball actually died before the series began, being referred to in flashbacks. Somewhat confusingly, in some cases, she appears as a white cat, while in other instances, she is black. Her replacement, Snowball II, is definitely black and is often seen sleeping near the family dog, Santa's Little Helper. She saved Homer from a blazing tree house in an episode, called *Old Yeller Belly*, but met a premature end after being run over by Dr. Hibbert.

Lisa then rescues a brown cat from an animal shelter, who becomes Snowball III. He too has a short-lived part in the series, drowning in an aquarium trying to catch the goldfish while Lisa is making food for him. The next cat was **Coltrane** (see page 133), who was subsequently referred to as Snowball IV.

The next feline added to the cast was Snowball V, who looks like Snowball II. Lisa chose this name as an economy measure – to avoid the necessity of buying a new food bowl. At one stage however, Snowball V strays off and becomes overweight after moving in with another family, and being temporarily rechristened as Smokey (see **Abby the Olympic Tabby**).

Snowball (2)

The tom cat said to have been responsible for introducing the characteristic of extra toes to the cats bred by the author Ernest Hemingway (see page 93).

Snowball (3)

Her DNA helped to convict a murderer (see page 73).

Snowdrift

A tom cat who had a major impact on the development of the Scottish fold bloodline (see page 107).

Socks

The cat who took over on the children's programme *Blue Peter* following Smudge's premature demise. Socks' arrival triggered considerable controversy because he was given the name despite viewers voting to call him Cookie. The programme makers preferred 'Socks' because of the white markings on his paws. Socks is a Ragdoll, which is a large, friendly breed. He has a fluffy coat and Siamese-type markings, and blue eyes (see also **Jill**, **Jack**, **Kari**, **Oke**, **Smudge** and **Cookie**).

Socks Clinton

A black and white cat who lived with American President Bill Clinton and his family. Socks was so popular that at the peak of his fame, he received over 10,000 letters and gifts daily. He published his diary account of the journey to America's most illustrious address in a book, *Socks Goes to Washington*, which proved to be a bestseller (see also page 60).

Sour Mash

One of the many cats kept by American writer Mark Twain (see also **Apollinaris**, **Buffalo Bill** and **Zoraster**, and page 19).

Spook

One of the supporting characters in **Top Cat** (see page 201), recognisable by his green fur. Like **Fancy-Fancy** (see page 141), he has a very chilled demeanour, perhaps more suggestive of California than New York where the stories are based.

Susie

The original founder of the Scottish fold bloodline who was killed in a road accident, leaving just her kitten **Snooks** to develop the bloodline. (See **Snooks** and page 106)

Sumo

Sumo's massive size meant that his presence was rarely overlooked at Hever Castle in Kent where he patrolled through the grounds. His name derives in part from the way in which Sumo wrestled with visitors, grabbing them around the neck. This ginger and white tomcat could also be quite terrifying after dark, sometimes leaping unexpectedly on to people's shoulders.

Sybil

Lived at Number 11 Downing Street with Chancellor Alastair Darling. (See page 64)

Sylvester J. Pussycat, Sr

This popular feline cartoon character first appeared in *Merrie Melodies* released by Warner Bros. Pictures in 1945 – although at this stage, he was unnamed. The film revolved around a heart-stricken lovebird, whose love goes sour to the extent that he tries to persuade the cat to end his life for

him. This arouses the cat's suspicions as he fears the bird is poisoned in some way, and he goes out of his way to avoid harming his feathered follower. In his next appearance, the striking black and white cat was christened Sylvester. His name was actually derived from the scientific name of the cat's northern wild ancestor – *Felis sylvestris*.

The bird and cat theme is reprised in a number of cartoons released between 1947 and 1964, with Tweety Bird (also known as Tweety Pie) repeatedly outwitting Sylvester. Their escapades brought screen awards including two Oscars, and the honour of appearing on an American postage stamp in 1998. This followed their appearance in a new cartoon series entitled *Sylvester and Tweety Mysteries* which began in 1995 and ran until 1999.

For 16 years from 1948, Sylvester appeared with other characters including Porky Pig in *Kitty Cornered* in 1946, and baby kangaroo Hippety Hopper. In 1955, he was teamed with Speedy Gonzales, a mouse from Mexico famed for his speed, but who was no more successful in outwitting his co-star. Sylvester appeared in over 90 of the *Loony Tunes and Merrie Melodies* cartoons which were produced between 1945 and 1966.

His creators took the decision at the outset to give him a distinctive red nose which resembled that of a circus clown, thereby helping to establish his personality. Sylvester's voice, devised by the actor Mel Blanc (1908–1989), is very distinctive, thanks to its pronounced lisp. It was based on that of another Warner Bros. character, Daffy Duck, but delivered more slowly which resulted in a distinctive, lower-pitched delivery.

Sylvester Junior

This young cat is a lesser-known *Loony Tunes* character, especially when compared with the fame of his father, Sylvester J. Pussycat Sr. (see above). He was first seen in

Pop 'Im, Pop, which was one of the cartoons in the Hippety Hopper series. Sylvester Junior was portrayed as a scaled-down, smaller version of his father with a rather irritating personality, who was often punished by having to put a paper bag over his head.

T is for Tabitha Twitchit and Trixie

Tabby

Belonged to American President Abraham Lincoln (see page 59).

Tabitha Twitchit

The mother of **Tom Kitten**, **Mittens** and **Moppet** in Beatrix Potter's story *The Tale of Tom Kitten* (see also **Moppet, Tom Kitten** and page 20).

Taki

Black Persian longhair queen owned by crime writer Raymond Chandler (1888–1959). He described her as his 'feline secretary', who always read the first drafts of his work.

Tao

The Siamese cat who featured in Sheila Burnford's novel *The Incredible Journey*, which told the tale of three pets desperate to return to their family and ultimately reunited with them against incredible odds. Published in 1961, the story was then made into a film two years later, which was released by Walt Disney. Interestingly, Sheila Burnford drew on a number of the characteristics which set Siamese apart from other breeds, such as their readiness to walk on a leash in her creation of Tao. The film was remade in 1993, with significant changes, not least that Tao had morphed from a Siamese into a Himalayan/colourpoint longhair cat called **Sassy**, which is a larger, long-haired breed albeit with similar markings (see page 184).

Tara

Holds the record for the greatest number of kittens. Tara was a Burmese-Siamese crossbreed who produced her litter of nineteen in 1970 at her Oxfordshire home. Sadly, four were stillborn.

Tata

See **Amberson** and **Tata** (see page 117).

Teeny and Weeny

A pair of Himalayan/colourpoint longhair cats kept by American homestyle television presenter and businesswoman Martha Stewart (see **Beethoven**).

Thomasina

Created by Paul Gallico, Thomasina appeared in a Walt Disney film (see page 22).

Tibs

A somewhat overlooked character in the book *The Hundred and One Dalmatians* written by Dodie Smith, which was made into a Disney cartoon feature film, *One Hundred and One Dalmatians* in 1961. In the book, Tibs was a female tabby cat with the rank of Lieutenant who helped to locate the missing puppies after they had been stolen, but was transformed into a male for the film, and reduced in rank to a Sergeant. Her colour was changed too, from blue to red for the film. The evil Cruella de Ville's own cat was not featured at all in the movie. According to the book however, she had forty-four kittens which were drowned by her heartless owner.

Tibert

Originally featured in the mediaeval French tale originally known as *Le Roman de Renart* which was written about 1175 by Pierre de Saint Cloud and now often simply referred to as *Reynard the Fox*. In this story, featuring a variety of animals, Tibert, Prince of Cats, was sent by the King Lion to bring Reynard back to court. He is nearly outwitted by Reynard however, when the fox suggests stopping off in a barn to catch mice. The cat becomes trapped in a snare left for the fox who has been stealing chickens, and is blamed by the local priest who finds him there. Luckily, Tibert just manages to escape with his life, having been badly beaten, and finally has his revenge by sitting on the gallows when the king hangs Reynard (see **Tybalt**).

Tibbles

The cat that single-handedly wiped out a species (see page 104).

Tiddler

Cat from Salisbury Cathedral (see **Captain**, **Ginge**, **Wolfie** and page 97).

Tiddles

The kitten who became a grossly overweight cat at Paddington Station (see page 83).

Tiger (1)

This is a very popular cat's name, especially for 'mackerel tabbies' which are distinguished by the darker stripes down each side of their body, rather like those of a tiger. Novelist Charlotte Brontë (1816–1855) had a pet cat of this name. She writes nostalgically to her sister Emily about

him while teaching in Brussels in 1843, reflecting on how he would become excited by being fed on pieces of mutton cooked in their kitchen at their home, in Haworth Parsonage in Yorkshire. During the previous year, Emily herself described cats as having more human feelings than virtually any other creature. She regarded cats as being more closely-allied to people than dogs.

Tiger (2)

Another of American President Calvin Coolidge's cats (see also **Blackie**, **Bounder**, **Climber**, a.k.a. **Mud**, and **Smokey**, also page 59).

Tiger (3)

A cat who lived at the Ritz Hotel (see page 115).

Tiger Tim

One of the main characters in the first ever cartoon-strip, *Mrs Hippo's Kindergarten* which began in 1889, initially as a supplement to a magazine called *The World and his Wife*, produced for domestic servants. Tiger Tim and the rest of the animals in these strips were created by Julius Stafford Baker (1869–1961). The strip then appeared in the *Daily Mirror* newspaper from April 1904, and continued through both world wars, with Stafford Baker's son taking over after the Second World War.

Tigger

Pooh's bouncy companion in A.A. Milne's classic children's story *The House at Pooh Corner*, published in 1928. His striped appearance was based on a stuffed toy kept by Milne's son, Christopher Robin, which is now on permanent display

in the Children's Reading Room at the Donnell Library Center in New Tork. Tigger and other characters from the book, including Piglet and Eeyore found their way to this unlikely venue after A.A. Milne (1882–1956) gave them to his American publisher E.P. Dutton during the 1940s. Then in 1988, they were passed on to be displayed in the library.

Tiggy

A library cat from Spalding, Lincolnshire (see page 95).

Tim

A stray red and white long-haired cat found in a Liverpool street by the young John Lennon (1940–1980). Tim became a particular favourite, among several cats which John grew up with. He used to cycle every day to a local fishmonger to buy food for the pets and once he started touring with the Beatles, he would regularly telephone his Aunt Mimi to ask about them (see also 130).

Timothy

The feline companion of crime writer Dorothy L. Sayers (1893–1957). She wrote about her white cat in two poems *For Timothy* and *War Cat*.

Tinker Toy

Probably the smallest cat ever to have existed, he was a Blue Point Himalayan (also known as a Colourpoint Longhair) born in the United States. Owned by Scott and Katrina Forbes of Taylorville, Illinois, Tinker Toy measured just 2.75 in (7 cm) at the shoulder, with his body being 7.5 in (19 cm) in length. He weighed 1.5 lb (0.68 kg). He died in 1997.

Tobias

A black cat with the ability to speak and other magical powers, Tobias featured in Sheila McCullough's series of books, *Tim and the Hidden People*. First published during the 1970s, these formed part of a reading scheme intended for children between 4 and 7 years of age, with Tim living in a house called *The Yard*.

Toby (1)

Lived at Carlisle station and frequently travelled much further afield by train (see page 84).

Toby (2)

The British shorthair in the television series *Desperate Housewives*.

Tom (1)

Up until the 1760s, male cats were known either as boars or rams. This changed following the publication of a fictional and rather raunchy tale called *The Life and Adventures of a Cat*. The hero of the anonymous story was *Tom the Cat*, and it proved to be so popular that the description of Tom was soon used universally to describe a male cat, marking the start of a tradition that has continued right down to the present day.

Tom (2)

A church cat from Bristol (see page 96).

Tom and Jerry

One of the most famous of all cartoon 'double acts', Tom and Jerry were the creation of famous animators William

Hanna and Joseph Barbera. There were 114 episodes produced for MGM between 1940 and 1957, and seven of these won Academy Awards. The idea for Tom and Jerry came from the cartoon *Puss gets the Boot,* which featured a cat named Jasper and an unnamed mouse. Initially, this was to be a one-off film, but public acclaim and an Academy Award nomination strengthened their creators' requests to be allowed to develop these characters. In the initial production, Tom was known as Jasper. The names of Tom and Jerry were chosen following a competition in the studio to devise suitable names for the main characters.

Tom Kitten (1)

The main character in Beatrix Potter's story *The Tale of Tom Kitten,* Tom lives with his sisters Mittens and **Moppet** and their mother **Tabitha Twitchit**. He also features in *The Tale of Samuel Whiskers* (see **Moppet** and page 20).

Tom Kitten (2)

Pet of American President John F. Kennedy's daughter Caroline. Tom Kitten died (no longer a kitten!) on August 21, 1962, and this was marked by obituaries in the press.

Tom Quartz (1)

Originally conceived as a character by American author Mark Twain (1835–1910). A large blue tom, he featured in Twain's semi-autobiographical story *Roughing It,* published in 1872. His owner Dick Baker was a miner, who took up quartz mining. Tom Quartz almost died when rocks were being dynamited and he found himself in the centre of the explosion. Luckily, he was thrown up into the air with only his dignity affected. Twain's inspiration may actually have come from a real cat of this name who lived in a Californian

mining cabin where he had stayed over the winter of 1864 while prospecting for gold (see page 19).

Tom Quartz (2)

American President Theodore Roosevelt (1858–1919) chose the name Tom Quartz for a kitten who lived at the White House from about 1902 onwards, and who was soon bossing Jack, the family's pet terrier. He would also sometimes grab important visitors to the White House, once even seizing the leg of the next Speaker of the House as he left. Roosevelt wrote about Tom Quartz's antics in a letter to his children.

Tommy

One of the cats which lived with Anne Frank in the attic of the Amsterdam house where she was trapped in the Second World War (see under **Bosch**).

Tony the Tiger

A character used to promote a popular breakfast cereal (see page 42).

Tonto

A red tabby, feline film star. He appeared in *Harry and Tonto* in 1974, and co-starred with Art Carney, in the role of Harry. The film is a comedy-drama variation of the 'on the road' movie theme, with the elderly widower and his cat travelling to California after being evicted from their condemned New York City apartment. Carney won an Academy Award for Best Actor and a Golden Globe, but according to his biographer, Michael Seth Starr, he never actually liked cats!

Top Cat

The star of a cartoon series based on a gang of alley cats living in New York, Top Cat and his associates engaged in a constant battle with the local policeman Officer Dibble. 'T.C.' as he was affectionately known, was a yellow cat with a flat purple hat and matching vest. The series was devised by the Hanna-Barbera team, and there were 30 episodes. These were first broadcast on the ABC network between September 1961 and April 1962, and were reissued on DVD in 2004.

These were not the only appearances of T.C. and his gang however, as they later appeared in *Yogi's Ark Lark*, alongside a host of other Hanna-Barbera characters including Yogi Bear, Huckleberry Hound and Snagglepuss, (a character based on a mountain lion). The cartoon was first shown in 1972 and represented an early attempt to raise environmental awareness, particularly amongst a younger and possibly more receptive audience.

Then in 1985, Top Cat appeared in *Yogi's Treasure Hunt*, heading off on a ship and instructing the other characters to search for missing valuables. Their attempts were hampered by Dick Dastardly and Muttley, from *Wackey Races* who swapped their car for a submarine in this adventure.

Top Cat and the gang were later reunited in a full-length movie made for television called *Top Cat and the Beverly Hills Cats*, which sees the action moving away from New York. This was broadcast in 1987, with the storyline revolving around an inheritance left to **Benny** (see page 122) by a wealthy old lady whose life he had saved, believing her to be a penniless bag lady.

The most recent appearance of Top Cat was in an episode of *Harvey Birdman, Attorney at Law*, although Spook did not take part in this cartoon. First seen in 2001, this series featured the former superhero Harvey Birdman and a host of other Hanna-Barbera characters.

Toto

Saved its owners from the eruption of Mount Vesuvius in 1944 (see page 71).

Toulouse

One of the three kittens starring in the *The Aristocats* (see page 23, **Berlioz, Duchess, Marie** and **Scat Cat**).

Towser

A distillery cat who is considered to be the world's champion mouser (see **Brooke, Dylan** and page 103).

Tish

Cats can carry on breeding for most of their lives, but it was remarkable when this black and white queen produced a litter of two lively kittens in June 1958, when she was 25 and then went on to successfully rear them. She lived at Maltby, Yorkshire.

Trim

A ship's cat who first sailed with the explorer Matthew Flinders in 1797, and journeyed to Australia with him (see page 79).

Trixie

A black and white cat owned by Henry Wriothesley, the third Earl of Southampton (1573–1624) who was an early patron of William Shakespeare. The story grew up that when the Earl was imprisoned in the Tower of London, his cat managed to find him, and climbed down the chimney into his cell. It seems more likely, however, that the Earl's wife smuggled the cat into the Tower to keep her husband

company while he was imprisoned there for two years. Trixie's loyalty is reflected in a painting which the Earl commissioned from John de Critz the Elder in 1603 when he was released, showing him with his faithful cat in the background. The painting now hangs in the Great Hall at Boughton House in Northamptonshire.

Twinkles

One member of a triumvirate of three black cats who feature in the children's story *Twinkles, Arthur and Puss* by Judith Kerr (see **Mog**), which follows their mysterious disappearance one day.

Tybalt

A Shakespearean character in *Romeo and Juliet*, drawing inspiration from Tibalt, an earlier anthropomorphic work (see **Tibert**).

U is for Ubasti and Unsinkable Sam

Ubasti

An alternative name for the Egyptian cat goddess, which was also known as **Pasht** and **Bast**.

Unsinkable Sam

Survived the torpedoing of three ships on which he was living during World War Two (see page 70).

V is for Vampire Cat of Nabéshima and Vivian

Vampire Cat of Nabéshima

A powerful figure in Japanese mythology which is the subject of tales remarkably similar to those of vampire bats in Europe. The Vampire Cat attacked a young maiden called O Toyo at night, killed her with a bite to the neck and sucked out her blood. The cat then buried her body and assumes her identity, progressing to attack her lover, Prince of Hizen, a member of the Nabéshima family. Drained progressively of blood, the prince's condition started to worsen dramatically. One of his soldiers called Ito Soda managed to evade the vampire's spell, and sees what is happening. By glaring at the vampire, he managed to protect the prince, and this ritual continues over the course of several nights, allowing the prince to regain his strength. The vampire cat was driven out of the palace and finally hunted down in the nearby mountains and killed.

Verdi

The name given to another of Martha Stewart's Himalayan/colourpoint longhair cats, named after composers (see **Beethoven** and **Vivaldi**).

Victoria

Named after Queen Victoria and the white cat in the musical *Cats*. Occasionally, she is portrayed with dark stripes on her flanks, or sometimes with dark tips to her ears (see page 32).

Vivaldi

A Himalayan or colourpoint longhair owned by the American businesswoman and broadcaster Martha Stewart (see **Beethoven** and **Verdi**).

Vivian

Resident with her companion **Marilyn** at London's Comedy Theatre (Ssee also **Marilyn** and page 34).

W is for Wan Ton and Woody

Wan Ton

A well-travelled Siamese cat who ended up in Heathrow airport rather than on Guam in the south-western Pacific (see page 84).

Webster

A black cat created by writer P.G. Wodehouse (1881–1975). He was the subject of *The Story of Webster*, part of the Mulliner Nights series and had an aristocratic air. Wodehouse also wrote another short story about cats in which Webster appeared, called *Cats will be Cats*. This featured Lady Widdrington, who liked cats general (although not Webster) and owned a bad-natured cat called Percy.

White Heather

Black and white Persian and favoured pet firstly of Queen Victoria (1819–1901) and then, after her death in 1901, of her son Edward VII and Queen Alexandra who were both pet-lovers. They also inherited White Heather's companion, Flypie. While the British Royal Family is well-known for its love of dogs, the only devoted cat-lover has been Queen Victoria. Her interest, particularly in Persian longhairs, helped to ensure their increasing popularity towards the end of the Nineteenth Century. In 1885, the artist Charles Burton Barber (1845–1894) was commissioned to create the only portrait of Queen Victoria which included a cat. Entitled *Cat and Dogs Belonging to the Queen*, it showed a pug, a dachshund and a fox terrier, all of whom appeared to have put aside their traditional instinct to chase the cat included alongside them.

Wila-Blite Pola of Sylva-Wyte

This Grand Champion Manx was the oldest cat to achieve a Best-in-Show win, when thirteen years old.

Wilberforce

The famous black and white resident of 10 Downing Street (see page 62). Originally, staff were arguing that the cat should be named after one of Britain's famous Prime Ministers, until the caretaker, seeing the bust of the anti-slavery campaigner William Wilberforce, decided to end the debate by settling on this name.

Wiley Catt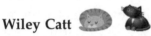

Drawn as a cartoon-strip character, he was a bobcat with reactionary views who supposedly lived in the Okefenokee Swamp in the southern American states. Wiley Catt was one of the central characters in Pogo, conceived by Walt Kelly, which appeared in various publications from 1948 until 1975.

William/Williamina

Beloved white cat of Charles Dickens (1812–1870). Her name was changed to Williamina when she gave birth to a litter of kitten in the kitchen. Feeling this was an unsuitable area in which to rear her offspring, she then carried them individually by the scruff of the neck into Dickens' study. He moved them back to the kitchen but was forced to relent when she repeatedly continued to return with them to the study. Dickens ended up keeping one of the kittens, which simply became known to everyone as **The Master's Cat** (see page 164).

Willie
Owned by American comedian George Burns (1886–1996).

Willow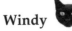
Another of the long line of cats that has appeared on the BBC children's programme *Blue Peter*. Willow was first seen as a kitten in September 1986 after Jack's death. Part of her role at a later stage was to encourage families to neuter their pets, to avoid adding to the large number of unwanted kittens born each year. She herself was neutered and left the programme in 1991 (see also **Jill**, **Jack**, **Kari**, **Oke**, **Smudge**, **Socks** and **Cookie**).

Windy
Famous pilot Guy Gibson's pet cat who flew combat missions with him during World War Two (see page 70).

Wolfie
Resident at Salisbury Cathedral (see page 97).

Woody
One of a pair of cats owned by French musical composer and performer Jean-Michel Jarre. The other was christened Allen, combining to create the name of the American film star Woody Allen.

X is for Xanthe

Xanthe

Pet of Marpessa (Athena Marpessa Gelyn), one of the characters on the Hogwarts School of Witchcraft and Wizardry website. Xanthe is described as a black cat, uniquely marked with a small grey spot. This site relates to the future, some years after the conclusion of the Harry Potter books (see also Crookshanks, page 134).

Y is for Yule Cat and Yum Yum

Yule Cat

Another mythical feline, who features in Icelandic culture. Each autumn, children are expected to help in preparing wool and receive gifts of new clothes in return.

Yum Yum

Koko's partner in the feline crimefighting series of books entitled *The Cat Who....*, created by Lilian Jackson Braun (see **Koko**).

Yum-Yum

The cat belonging to British writer Brian Aldiss, whose works include *Home Life with Cats*, published in 1992, although he is also well-known as a science fiction author.

Z is for Zara and Zoraster

Zap and **Zip**

Two black cats owned by the American basketball star Wilt Chamberlain (1936–1999).

Zara

Kept by the British statesman Horace Walpole (1717–1797) (see also **Selma**).

Zizi

An elegant Turkish Angora, and one of a number of cats belonging to the French writer Théophile Gautier (1811–1872). Zizi loved to walk over the keys of the piano. She was referred to in his book *La Ménagerie Intime*, published in 1869. This work is known in English as *My Household Pets* (see page 162).

Zoraster

One of Mark Twain's cats (see also **Apollinaris, Buffalo Bill and Sour Mash**, and page 19).

Bibliography

Alderton, David, *Your Cat Interpreter* (Reader's Digest, 2006)
Ayto, John, *Brewer's Dictionary of Phase and Fable* (17th edition) (Collins, 2006)
Bryant, Mark, *The Complete Lexicat : A Cat Name Compendium* (Robson Books, 1992)
Greene, David, *Incredible Cats : The Secret Powers of Your Pet* (Methuen, 1984)
Haigh, G., *Peter the Lord's Cat : And Other Unexpected Obituaries from Wisden* (Aurum Press Ltd., 2006)
MacDonogh, Katharine, *Reigning Cats and Dogs* (Fourth Estate, 1999)
Morris, Desmond, *Cat World : A Feline Encyclopedia* (Ebury Press, 1996)
Stall, Sam, *100 Cats Who Changed Civilisation* (Quirk Books, 2007)
Tremain, Ruthven, *The Animals' Who's Who* (Routledge & Kegan Paul, 1982)
Wood, Gerald L., *Guinness Book of Pet Records* (Guinness Books, 1984)

Websites
http://en.wikipedia.org/wiki/Category:Famous_cats
http://home.comcast.net/~sharonday7/Presidents/AP060403.htm
http://members.aol.com/meow103476/catpeople.html
http://toolooney.goldenagecartoons.com/sylvester.htm
http://www.best-cat-art.com/cartoon-cats.html
http://www.catsmusical.com/contents/

http://www.citizenlunchbox.com/famous/cats.html
http://www.gotcats.org/celebritycats.html
http://www.moggies.co.uk/index.html
http://www.pawsonline.info/feline_statistics.htm
http://www.paulgallico.info/
http://www.purr-n-fur.org.uk/featuring/index.html
http://www.reallyuseful.com/rug/shows/cats/
 show.htm
http://www.scattycats.com/List_of_historical_cats.html
http://www.sylvester-cat.com/?about

Acknowledgements

The author and publisher would like to thank the following for their assistance in producing this book: Sue Blackhall for her diligent work on editing the typescript and Fiona Shoop for taking or sourcing all of the photographs. With grateful thanks to Robert Harrop, Whiskas, Greens, Cheffins Auctioneers, DMG antiques fairs and Thomaston Place Auction Galleries for their help in supplying images or allowing photographs to be taken on their premises.

Index

INDEX